Jewels

That Made History

100 Stones, Myths & Legends

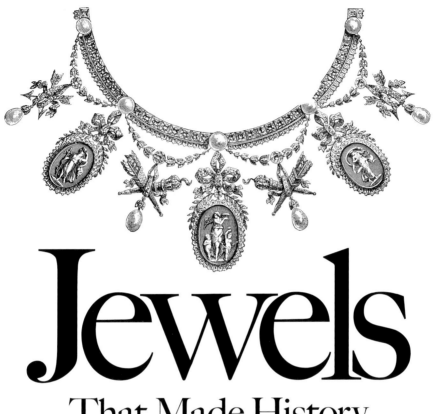

Jewels

That Made History

100 Stones, Myths & Legends

by
Stellene Volandes

RIZZOLI
NEW YORK

New York Paris London Milan

Table of Contents

5

This is not the history of jewelry. And it is not a

this book is a highly opinionated chronicle of

I hope, an invitation to see each jewel at the cen-

how I fell so deeply in love with jewelry, and why, after

well. Each moment merce, passion, and fate coalescing in a jewel. I

nouveau brooch without imagining

cameo without considering the coronation

the next time someone blames Marie

French Revolution, you will guide them to point

to take jewelry out of the safe, glass

stage of history. I hope, after reading it, you

history of the world. Rather,

select moments where these forces collide. It is also,

ter of these moments through that cultural crash. It is

reading this, I anticipate you might as

attempts to isolate the forces of empire, conflict, com-

hope 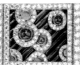 you will never again look at an art

Commodore Perry sailing into Japan, or see a

of Napoleon or the excavations at Pompeii, and maybe,

Antoinette for the

at a necklace instead. This book is, above all, a call

vitrine, or velvet box, and place it on the grand

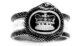 will always expect it to appear there.

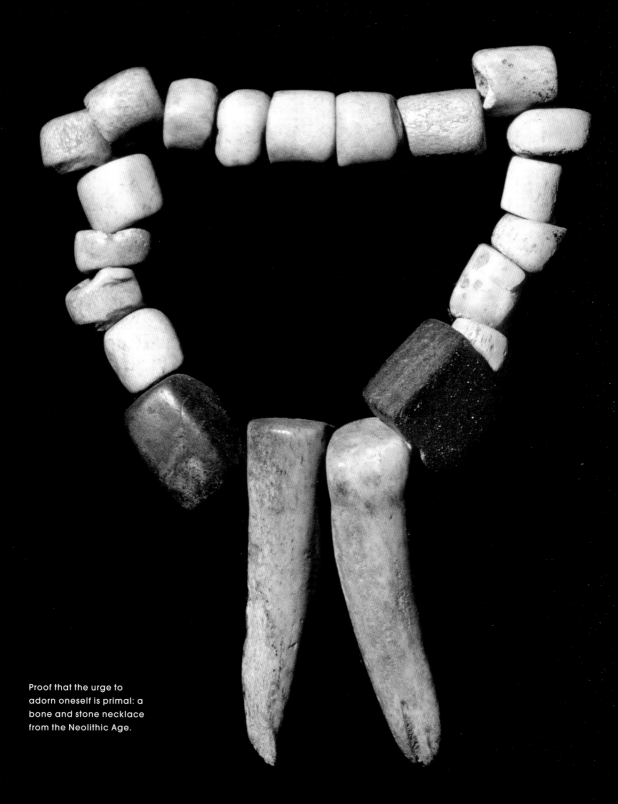

Proof that the urge to adorn oneself is primal: a bone and stone necklace from the Neolithic Age.

In the Beginning

When does jewelry start? How far back is it possible to go? In the beginning, there were jewels. Evidence exists of pierced ivory beads from the Paleolithic era, and even in the earliest graves the primal need for adornment is clear. Ancient Egyptian tombs from 4400 B.C. hold evidence of beads made from shells or minerals or chopped pebbles. The wealth of Mesopotamia—"the cradle of civilization"—meant that almost everyone adorned themselves with at least one piece almost all the time, some with gold or silver, some with imported jasper or carnelian. A gold-lined tomb unearthed in Pylos dating from the Bronze Age contained gold and bronze, amber from the Baltic, amethyst from Egypt, and carnelian from the Arabian Peninsula and India.

If there are people, there will be jewelry. It will be fashioned from the natural treasures of their territories or the bounty of existing trade routes. It will be used to display power and to ensure protection. And if it is spared from the fates of history, it will remain.

1292 B.C.

Follow the lapis lazuli. And the carnelian. And the turquoise. In ancient Egypt, they might have been known as The Big Three. If you walk through the Egyptian galleries at the Metropolitan Museum of Art, their dominance reveals itself. The lapis was imported from Afghanistan. The carnelian mined right there in Egypt, the turquoise discovered in southwestern Sinai. In lapis's deep blue they saw the heavens. In carnelian's red hues and turquoise's greenish blue they imbued powers of protection against evil. The craftsmanship of Egyptian goldsmiths was legendary and the signature palette of ancient Egyptian jewelry is strong. Then the Greeks came, and then the Romans. As we will see often in this chronicle of stones and gold and history, jewelry is evidence of a civilization's own natural resources; it is proof of the riches of the land it conquered or had access to. It speaks to its legends and beliefs, and also charts its downfall.

The Jewelry of a King

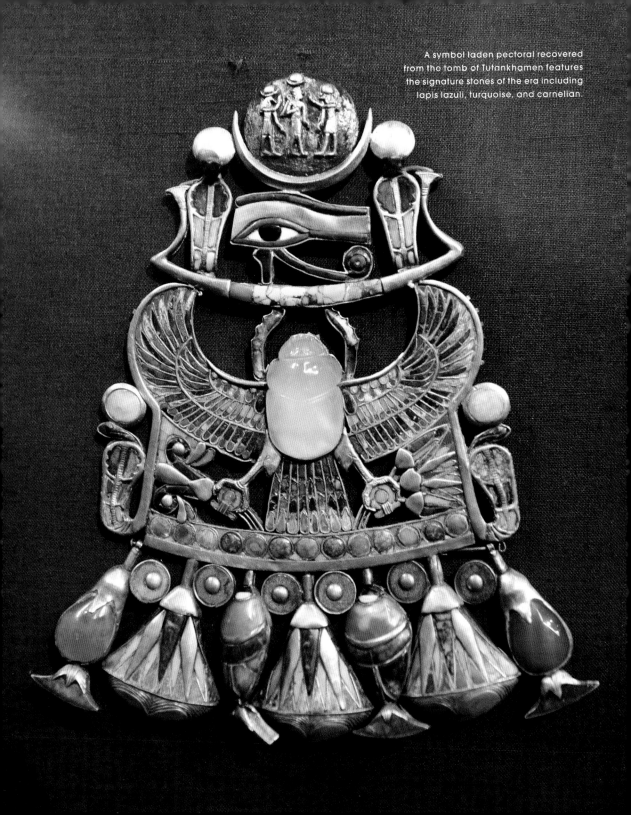

A symbol laden pectoral recovered from the tomb of Tutankhamen features the signature stones of the era including lapis lazuli, turquoise, and carnelian.

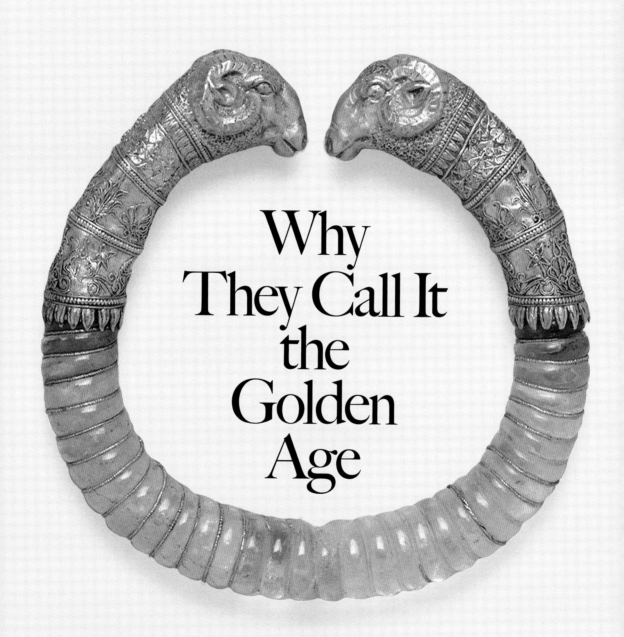

Alexander the Great built an empire. These Hellenistic-period rock-crystal-and-gold cuffs are proof of its success.

Why They Call It the Golden Age

333 B.C.

The history of jewelry is the history of conquest. There is a pair of bracelets in the Greek and Roman Galleries at New York's Metropolitan Museum of Art: two golden rams with a base of polished rock crystal shaped to appear as if it is twisting (Hellenistic, 330-300 B.C.). They are surrounded by vitrines holding similar golden treasures of the same period. How did one precious metal come to dominate an empire? It might be too simple to point to Alexander the Great—the earlier Minoans and the Myceneans were both skilled at goldsmithing—but it would not be inaccurate. Let's count down his conquering and see where we land: In 336 B.C., after having been tutored by Aristotle, he succeeds his father Philip. By 333 B.C. he defeats the Persians at the Battle of Issus and is rewarded with all the gold in Persia (it takes 20,000 mules and 5,000 camels to transport). The victories, and the riches, keep coming, and keep returning to Greece. More gold, more new materials, more knowledge of how to create something beautiful out of it. In 332 B.C., Alexander conquers Egypt, in 327 he enters Babylon, in 327 he invades North India. And in 323 he dies, having impacted jewelry forever.

Jewelry Becomes Law

If one needs to prove the case that jewelry holds power, may we place into evidence the Justinian Code? In the Byzantine Empire, rich with precious metals and gems, jewels became loaded symbols of status. The Empire's geography made it an ideal spot for trade so it was replete with pearls and garnets and beryls from India and Persia, and it had its own gold mines within its boundaries. So rich did these jewels become with meaning that Emperor Justinian enacted legislative action to consolidate his power—to make sure it was clear who was boss. Entered into the Justinian Code of 529 A.D is a clause outlining rules of adornments: sapphires, emeralds, and pearls were for the Emperor only. But every man had the right to wear a gold ring. The Empress, the former actress and fierce social reformer Theodora, took full advantage of the Emperor's treasury. There she is in the San Vitale Chapel rendered in small tiles, dripping in pearls and emeralds, and rubies, garnets, and gold. She is an early and powerful example of the use of jewelry to assert position and power. And she did it well. So well, in fact, that centuries later, a visit to see her portrait in Ravenna by a Parisian fashion designer named Gabrielle Chanel and a young Sicilian jeweler named Fulco di Verdura allegedly inspired another turning point in our history.

529 A.D.

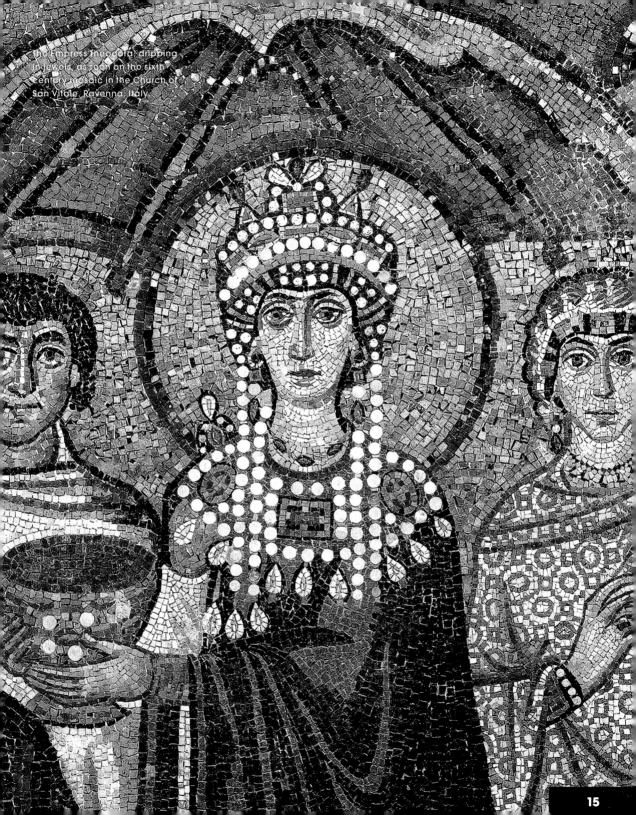

The Empress Theodora, dripping in jewels, as seen on the sixth century mosaic in the Church of San Vitale, Ravenna, Italy

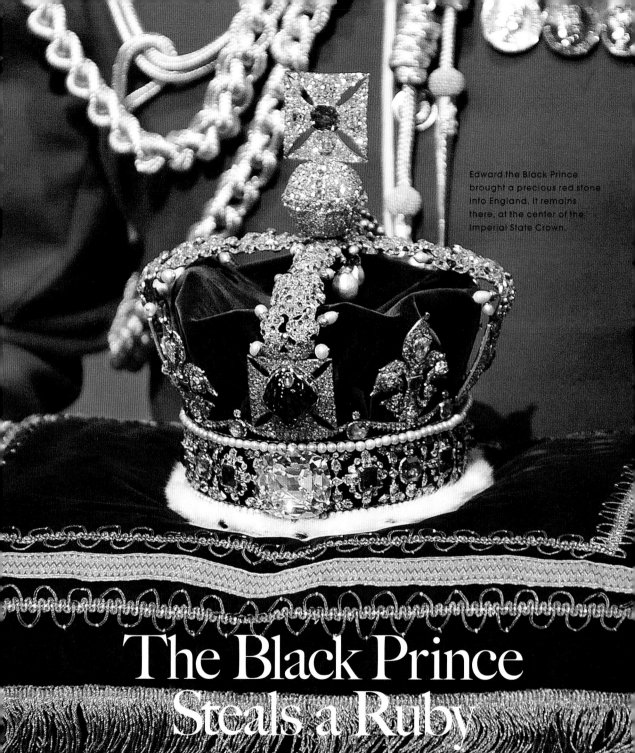

Edward the Black Prince brought a precious red stone into England. It remains there, at the center of the Imperial State Crown.

The Black Prince
Steals a Ruby

1371

Or so he thought. That large red stone at the center of England's Imperial State Crown is known as The Black Prince's Ruby but is, in fact, a 170-carat red spinel. Sometimes called the Great Imposter, it is said to have been stolen in 1371 from the body of the Sultan of Granada by Pedro the Cruel. Edward of Woodstock (the Black Prince) offered Don Pedro shelter; Don Pedro offered the Black Prince untold treasures, including one massive red stone, in return. The "Black Prince's Ruby" was worn on battlefields by Henry V at Agincourt (where it might have saved his life: when the king was struck in the head, not only did he survive, but the stone remained intact) and Richard III at the Battle of Bosworth Field (where it didn't bring quite the same kind of luck). Most famously, it is now the red stone above the Cullinan diamond on the Imperial State Crown. It is one of the most valuable gemstones in one of the most treasured jewelry collections in the world but it has sometimes been thought to bring a curse along with it. Queen Elizabeth's long and glorious reign has forced that myth to be reconsidered—as have recent auction prices for rare, high quality spinels.

EDWARD the BLACK PRINCE

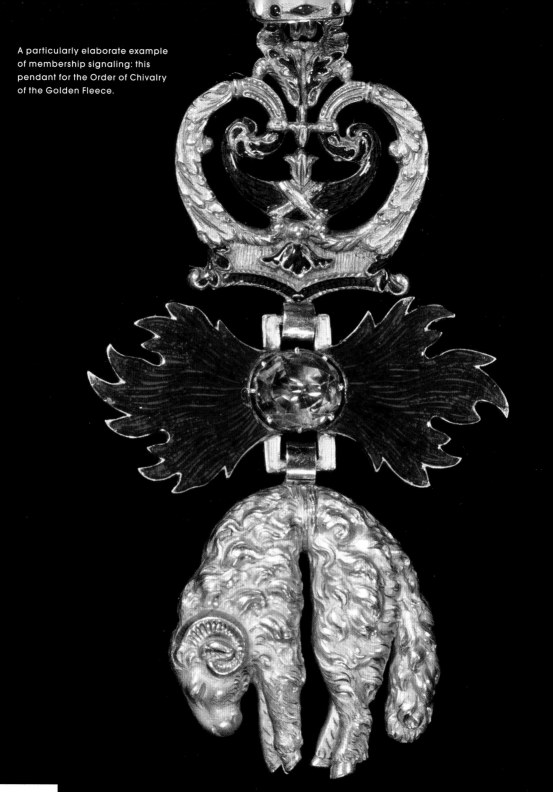

A particularly elaborate example of membership signaling: this pendant for the Order of Chivalry of the Golden Fleece.

A Badge of Honor

Think of it as a medieval knight's fraternity ring. The Order of the Golden Fleece was established as a Catholic order of chivalry by Philip the Good, Duke of Burgundy. Induction is marked by a *Toison d'Or*, a golden ram's fleece (inspired by the mythological Jason) often suspended on a red satin ribbon, but also made from bands of gold, and occasionally, diamonds, sapphires, and rubies. One such bedazzled Golden Fleece *Toison* dating from 1820 and from the property of the Bourbon family, was sold at Sotheby's in 2018 for 1.6 million Swiss Francs. Membership has its privileges.

1430

The First Engagement Ring

Now that was a rock:
detail of the ring received
by Mary of Burgundy.

They did call her Mary the Rich but sources suggest that the union of Mary of Burgundy and the Archduke Maximilian of Austria was a true love affair, although they admit it was indeed an advantageous engagement for all parties. Mary's father Charles the Bold of Burgundy needed the military strength of Maximilian's Hapsburg clan, and Maximilian's tribe needed the Burgundian coffers. Legend says that Maximilian, who would be named Holy Ro-

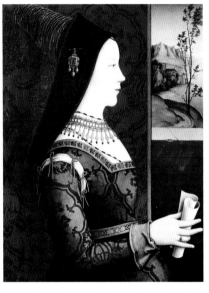

man Emperor Maximilian I in 1508, set off to Burgundy and received tokens of silver and gold for support along the way, enough that he was able to buy his intended a gold ring with diamonds set in the shape of an "M." (Some cite the less romantic idea that it was not a love-addled Maximilian that chose the ring but his shrewdly strategic counsel.) Wedding tradition up until this point had been to offer bands of metal to formalize the official union, but the idea of an engagement ring, a promise of betrothal, and a diamond one at that, was radical. The revo-

lutionary romance was, unfortunately, short-lived: Mary became ruler of Burgundy and battles were won and territories conquered, but she died five years into their marriage after being thrown from a horse.

1498

Next time you find yourself in front of a portrait of a queen or a nobleman, examine the jewelry, note the date, and mark the trade routes. And if it's a sixteenth-century painting and you're wondering where all those pearls are coming from, the ones adorning bodices and woven through hair, the ones around necks and hanging from ears, one of the lines should point to the Americas. As any study of royal and aristocratic portraiture of the time shows, pearls were power. Demand was high, and the pursuit of sources outside of the long-dominant Persian Gulf region, feverish. Pearls were said to be at the top of the list of what Ferdinand and Isabella wanted from Christopher Columbus's exploits. While he did not succeed on his first voyage, on his second voyage to the New World,

Look for the Pearls!

he ventured further south near Venezuela, where he discovered what he—and his royal sponsors—were looking for: a new source of pearls. Their abundant supply enriched the Spanish monarchy, adorned nobles, and livened up their portraits for centuries.

A treasure map of expeditions and conquests across the Indian Ocean, the Persian Gulf, India and North Africa.

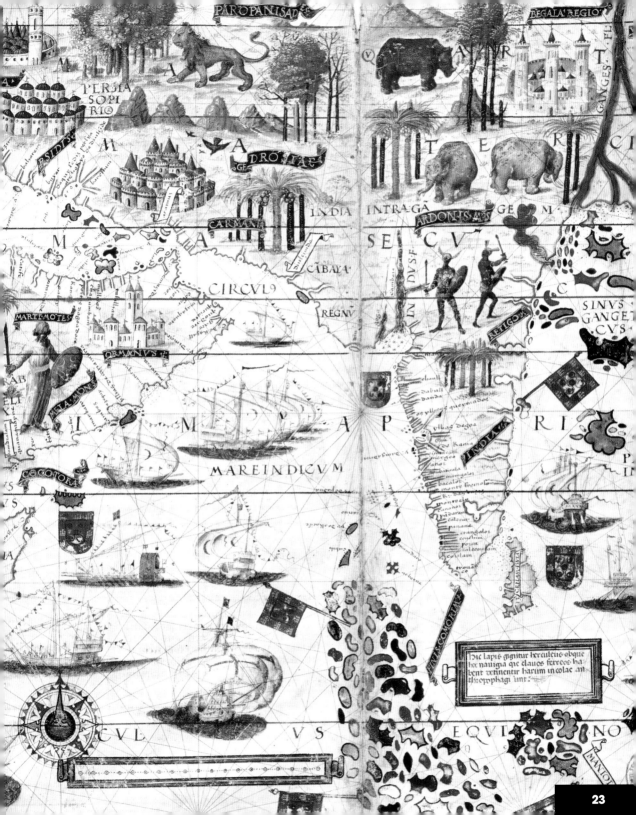

PAROPANISAD

BEGALA' REGIOT

GANGES· FL·

PERSIA
SOPIRIO

DROTIAE·

TER

CI

INDIA INTRA GĀ

CARMANA

INDIA INTRA GĀ

ARDONIS· ATS·

GE·

M

SE·

CV

CĀBAYA

CIRCVLʒ

REGNV

IN

DVS·F·

RETICO·

SINVS
GANGE
CVS

MARTE·MOTES

ORMANVS·

I

M

A

P

R·I·

AETA·MONS

INDIA·BA·

P.
I

COCOTORA

MARE INDICVM

FINIS·COMORIE

hic lapis gignitur herculeus obque
hic nauigia que claues ferreos ha
bent detinentur harum incolae an
thropophagi sunt.

CVL

VS

EQVI

NO·

MANIO

23

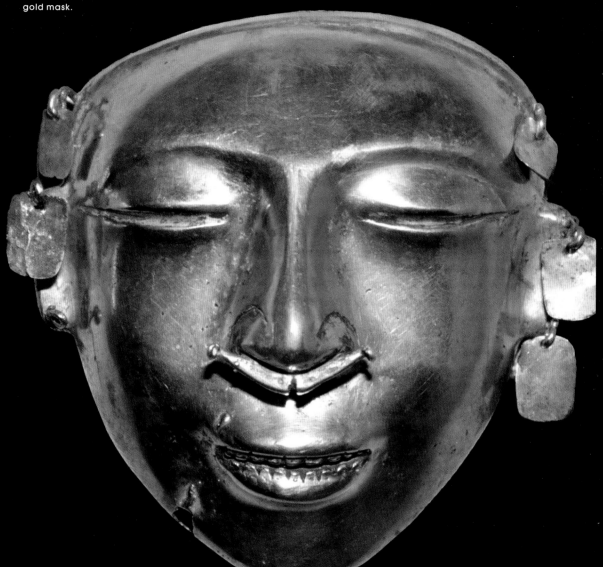

A Pre-Columbian
gold mask.

Which Way
to El Dorado?

1530

The Spanish conquerors' tales heralding a city of gold in the New World may have marked the end of the glorious tradition it celebrated. There is evidence of a goldsmithing culture in Colombia from the first millennium B.C. The material itself was abundant, especially in the country's riverbeds, and was traded as raw material and then designed into objects and ornaments, including arm cuffs and nose ornaments and headdresses, and they, like so many civilizations, buried gold objects to commemorate the dead. The practice of advanced goldsmithing ceased when indigenous American societies lost access to gold during the Spanish conquest.

The Strands of History

How many stories can one jewel possibly tell? How many tales of marriage, exile, and feuding dynasties, of revolution, and the coronations of kings and queens? They are but six strands of prized mollusk, but the Hanoverian Pearls cover all of the above. They began as a wedding gift, a dowry actually, when Pope Clement VII arranged for his noble Italian niece Catherine de Medici to marry Henry II of France in 1533. The pearls move into another royal household when Catherine's son married Mary Queen of Scots, and the lucky (or "lucky") bride received some of her mother-in-law's jewels. In 1587, Mary lost her head, but she had been stripped of the pearls years earlier when they were sold, at reportedly a very fair price, to her rival and cousin Queen Elizabeth I. Through inheritance and a royal marriage into the kingdom of Bohemia, the pearls were safely out of England when Oliver Cromwell took power and melted down the treasury, but they made their way back (another marriage!) and eventually into the vault of Queen Victoria. Upon her death she bequeathed some of the pearls to her daughters and others to the state. Some currently embellish the Imperial State Crown at the Tower of London, worn by Queen Elizabeth at her coronation, and powerfully present on a velvet pillow (at three pounds it has become too heavy for her to wear) at every State Opening of Parliament.

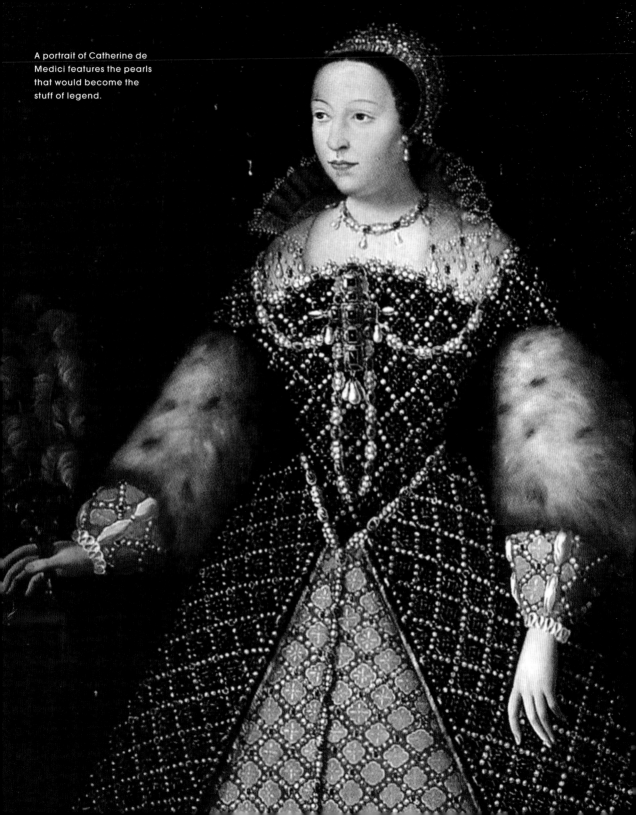

A portrait of Catherine de Medici features the pearls that would become the stuff of legend.

There is a portrait of Anne Boleyn in London's National Portrait Gallery wearing a pearl necklace from which is suspended the golden initial "B." Try as the King might to erase her from history (he had her executed to make way for Jane Seymour), the legend of Anne Boleyn lives on—as does the mystery of her necklace. Where could it be now? Theories abound. Henry and Anne's courtship began with a jewel—one of his first love letters to Anne came with a gold bracelet—and their love also ended with one. Legend has it that Anne discovered Henry's affair with Jane Seymour when she spotted a locket around Jane's neck at court. Inside? A picture of the King himself. But because of this portrait of Anne, it is the fate of her "B" necklace that has most intrigued historians. It is believed, and hoped, that some of Boleyn's jewelry was stashed away by loyalists and held for her daughter Elizabeth I. An "A" necklace in an early portrait of the Virgin Queen seems to support this claim. The majority of Anne's treasures, however, are believed to have been melted down or sold off, which was not unusual at the time. There is a persistent—albeit unsubstantiated—rumor that a handful of the pearls from the "B" necklace remained with the Crown and that they now are among the stones in the Imperial State Crown. Which would

1536

mean of course that Henry try as he might, was not able to erase Anne from history: the Imperial State Crown anointed Elizabeth II at her coronation.

That's Boleyn with a "B"

Henry VIII's wife Anne Boleyn with her initial pendant. Where could it be now?

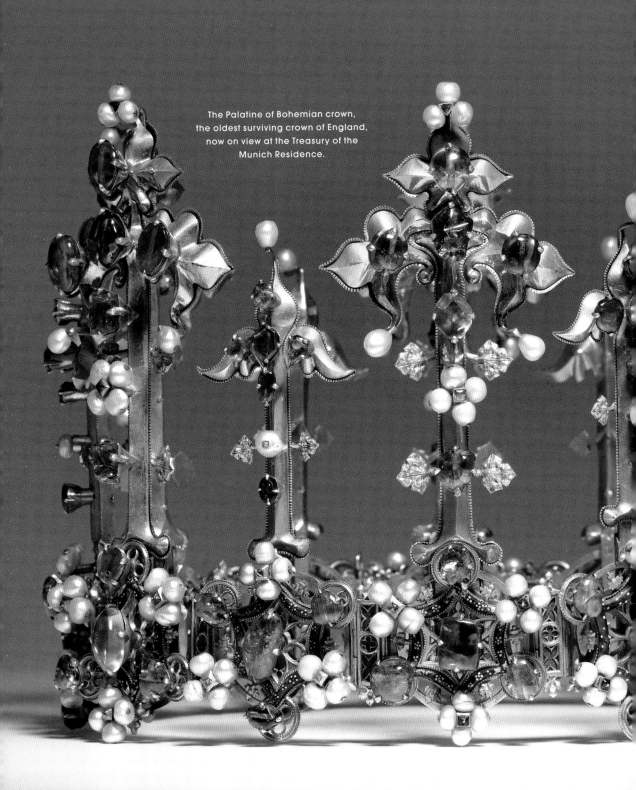

The Palatine of Bohemian crown,
the oldest surviving crown of England,
now on view at the Treasury of the
Munich Residence.

The Treasury of the Munich Residence is the story of one man's visionary understanding of the power of jewels to speak history. Duke Albrecht V stipulated in his will that "hereditary and dynastic jewels" be united in an "unsaleable treasure." His descendants continued the tradition. The Treasury now holds the impressive Bavarian Crown Jewels and, notably, the headpiece known as the Palatine Crown, possibly the oldest surviving crown of England, from 1370. It arrived as an item in Princess Blanche of England's dowry (the daughter of King Henry IV of England), but it is thought to have originated in the collection of Queen Anne of Bohemia, wife of Richard II. Monarchies may be abolished, empires rise and fall, but these jewels, thanks to the valiant efforts of Duke Albrecht, have remained.

Please Save the Jewels

Pearls Become Queen

Look at her: Pearls everywhere. A stone-laden crown beside her. Is there any question this is a woman at the height of her power? Which is exactly the point. Few monarchs manipulated symbol as skillfully as Elizabeth I did, and jewelry was an integral instrument in this endeavor. Pearls proved an effective and enduring signifier of her reign. They connected her clearly to a royal past—rumors abounded that several of her pearl drops had been taken directly from the collection of her mother Anne Boleyn, second wife of Henry VIII—which spoke directly back to the equally powerful rumors that Elizabeth was illegitimate. The pearls reminded the public of the wealth her reign had brought to England and her success in extending its influence overseas. They—treasures of the sea—are also reminders of her win over the Spanish by sea, and perhaps even evidence of treasures looted from the Spanish fleet post-defeat. (Spain, thanks to its expeditions to the New World, was particularly pearl-rich.) They are also testament to her survival. Multiple strands shown here are the famed Hanover pearls, a gift from Catherine de Medici to her daughter-in-law, Mary, Queen of Scots,

1588

the mastermind of a 1587 plot to overthrow her cousin Elizabeth. The Virgin Queen executed Mary in response and got the pearl necklaces in return.

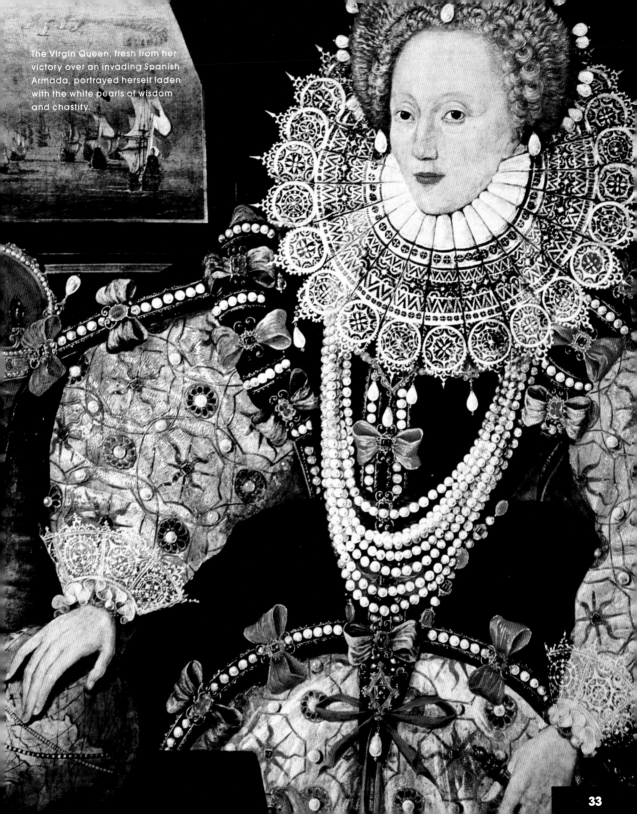

The Virgin Queen, fresh from her victory over an invading Spanish Armada, portrayed herself laden with the white pearls of wisdom and chastity.

We can't really blame it all on his pearl earring. Charles I of England was rarely without it, a perfect oval topped with a gold cross that he wore, from his teen-age years until his death, on his left ear. But the extravagance of his father James did put the country in debt and Charles's refusal to play nice with Parliament on matters of taxation did lead to civil war which led to his execution for treason which led to the rise of Oliver Cromwell which led to the destruction of the Crown Jewels of England. (Cromwell had them taken apart and melted down or destroyed.) But Charles I was a believer until the end. He wore that pearl earring to his execution, and it, unlike some of England's original Crown Jewels, still resides there, safe in an ancestral home.

His Kingdom for a Pearl?

1649

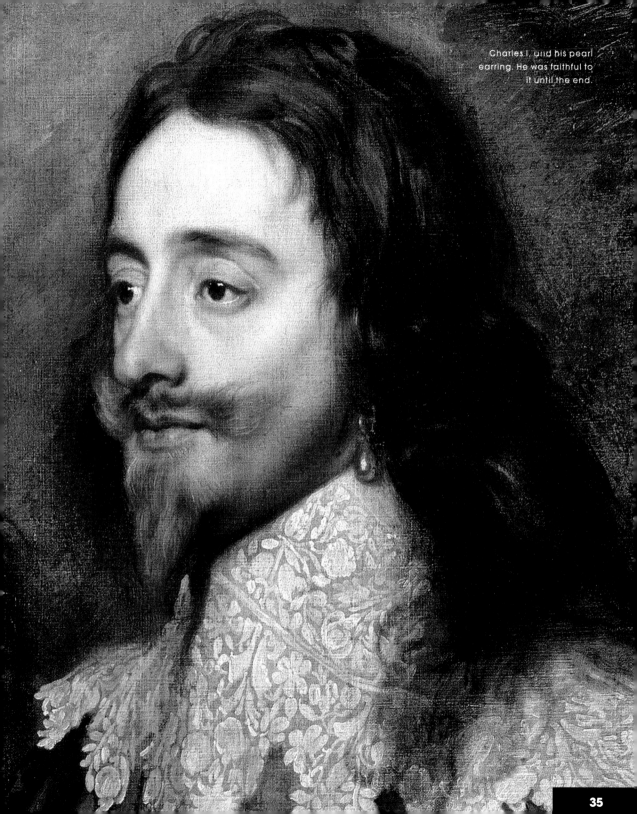

Charles I, and his pearl earring. He was faithful to it until the end.

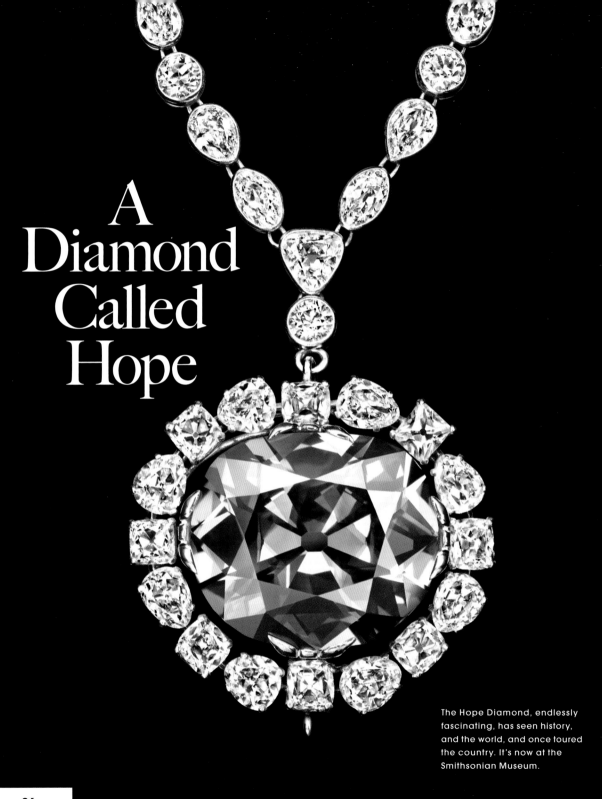

A Diamond Called Hope

The Hope Diamond, endlessly fascinating, has seen history, and the world, and once toured the country. It's now at the Smithsonian Museum.

The journey of a diamond reveals multitudes: the impact of migratory patterns on a stone's life; tales of greed and of desire. The legendary 110-carat blue stone was first sold to Louis XIV in 1668 by the diamond merchant Jean-Baptiste Tavernier. Tavernier's travels to Persia and India in the seventeenth century included a visit to the Golconda diamond mines in India, the first European to do so. The stone was referred to as the Tavernier Blue for a short while until, naturally, the title Blue Diamond of the Crown won favor. Then the Revolution came—some in fact, blame a rumored diamond curse for the royal beheadings—and the diamond went to state coffers, then was stolen during the looting of the treasury in 1792. In 1812 it mysteriously reappeared, in the hands of a London diamond merchant. Did it get there via the "very acquisitive" King George IV and his problem with paying off his debts? Perhaps. It certainly passed through the hands of Henry Philip Hope (hence its name) and several of his descendants until landing at Cartier, who reset it for client, Evalyn Walsh McLean, wife of the owner of *The Washington Post*. When she died, after wearing it well, and often, in 1946, Harry Winston acquired her entire collection. The Hope Diamond did its Rainbow Tour as part of Winston's Court of Jewels before the American jeweler donated it to the Smithsonian Institution, where about five million people a year now pay their respects.

1668

1670

The birth of the travel tradition of the Grand Tour is often cited as Richard Lassels' *The Voyage of Italy*. It spawned copycat travel guides and inspired generations of well-heeled Englishmen and Northern Europeans to travel across Europe, particularly to classical sites in Florence, Venice, and Rome, and also to France. The Grand Tour becomes an essential part of a well-born man's cultural education, though by many accounts, a good time was also had by all. For our purposes, let's focus less on the itineraries and shenanigans, and more on the souvenirs. After eighteen months of travel surveying ancient wonders in foreign lands, these travelers often brought back artifacts from their journeys. Cameos, intaglios, and micro mosaics soon began to appear on fashionable lapels. The trend inspired a Grand Tour souvenir industry for those who could not manage to stash an authentic Roman coin in their valise. As the world expands, so too does the face of jewelry.

And We Are Off on a Grand Tour!

Visits to ancient sites like the Pantheon inspired historical and mythological jewelry motifs.

One of the
All-Time Greats

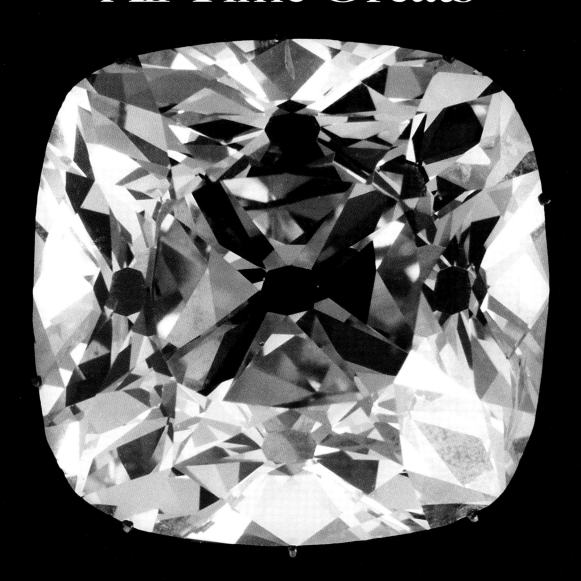

Up close with the Regent
Diamond, considered by many
to be one of history's greatest.

It is from the great Indian mines of Golconda, and considered one of the finest in the world. Its cut is brilliant and the stone nearly flawless. But the mythical allure of the Regent Diamond stems from other sources: 426 carats; two years of painstaking, meticulous cutting; bought by Philippe d'Orléans, Regent of France; worn by Louis XV on his hat, Louis XVI on his crown, and Marie Antoinette on black velvet; stolen; retrieved; displayed on Napoleon's sword; centered on Empress Eugenie's diadem; saved from the sale of the French Crown Jewels in 1887 and an invading German Army in 1940—hidden behind a stone panel at a chateau in Chambord. Visit it at the Apollon Gallery at the Louvre to marvel at its beauty, its history, and its survival.

1698

A depiction of life at the court of Golconda, India, home of legendary diamond mines.

The End of Golconda

"We search for stones from Goleonda," someone once told me, "the way art dealers look for a missing Van Gogh." Golconda, a fourteenth century Indian sultanate about six miles west of present-day Hyderabad, was known for its elaborate fort and diamond mines. During the Renaissance, *Golkonda* came to be synonymous with great wealth, and the name is still spoken with reverence by deep-pocketed diamond traders and collectors. These aficionados scour jewelry auction catalogs for the rare occasions when the word appears in boldface type. The Golconda designation at an auction suggests that a stone's provenance can be traced all the way back to those historic mines. From a gemologist's perspective, diamonds from Golconda are distinguished by their complete lack of nitrogen—an absence necessary to

1725

achieve Type IIa designation for any diamond, regardless of origin. Nitrogen gives a stone a yellowish tinge; diamonds without it appear whiter than white, or as clear as a drop of water. For nearly two thousand years the mines at Golconda were the only source of diamonds on earth (South Africa's deposits were not discovered until the late nineteenth century), but exclusivity took its toll. By 1725 the insatiable appetites of Indi-

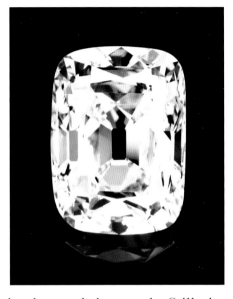

an maharajas and European royals had exhausted the supply. Still, the ancient luster remains. The world's most famous diamonds are Golcondas: the Koh-I-Noor diamond, at the center of the Queen Mother's crown in the Tower of London; the Regent Diamond, which once adorned the hilt of Napoleon's sword; the Idol's Eye, which served as the ransom paid by the sheik of Kashmir for the release of Princess Rashidah; the Agra, said to have been worn by the Mughal emperor Babur in the center of his turban; the Wittelsbach, originally sold to King Philip IV of Spain for the dowry of his daughter (and most recently acquired by Graff Diamonds owner Laurence Graff at Christie's in 2008 for $24.3 million), the Great Moghul Diamond, a 242-carat specimen whose current location is one of the enduring mysteries among Golconda hunters.

The Past is Present

We could, if we were like that, spend a lot of time in tombs here. Archeology and jewelry make strange but ultimately very productive bedfellows. And as the science of excavating the past became formalized in the 18th century, its impact on design became more pronounced. In almost every tomb discovered across civilizations, jewelry is found with the dead, jewelry is elaborately painted in murals, jewelry is discovered clutched in the hand of a woman caught by an explosion, unawares. And with each piece of jewelry brought up from below, a designer's inspiration is fired. So begins a period of jewels looking to the past, reflecting the culture's newfound access to its artifacts. The excavation of Pompeii begins this year. Ancient motifs and materials slowly appear in jewelry. Not long after, the

The discovery of ruins of the Roman Forum ignited a trend that resurrected ancient techniques.

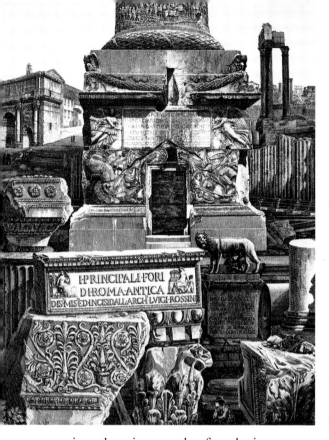

tombs of the mysterious Etruscans, a highly evolved civilization that valued art and culture and prospered along the coast of Italy from the 8th to the 1st century B.C. are found outside of Rome. The jewels unearthed here are highly crafted gold pieces exhibiting long forgotten techniques of granulation and filigree and the discoveries send jewelers in search of techniques to replicate the finely wrought Etruscan gold. A Roman named Fortunato Pio Castellani discovers the secret and soon, his what come to be called Etruscan Revival pieces, become highly coveted.

1748

How to Break a Heart (and Gain a Diamond)

Catherine the Great of Russia had a fondness for men and for jewelry (her horse was named Diamond), and often, the two passions crossed paths. The 189-carat Golconda diamond that sits at the top of her Imperial Scepter is known as the Orlov, after the man who is said to have journeyed all the way to Amsterdam to bargain with an Iranian millionaire to get Catherine the diamond she wanted. (A previous offer to the owner had been rejected.) Orlov had proven his dedication to his lover before—he led the coup that overthrew her husband and brought her to power—but by 1775 Catherine had moved on to Grigory Potemkin. One legend has it that Orlov believed if he got her the diamond she desired it would prove his power and his love and might help win her back. More likely, Catherine sent him to Amsterdam to haggle on her behalf, as bargaining was behavior unbecoming of an Empress. Either way, the Golconda made it back to Russia and into the Scepter that remains in the Kremlin Diamond Fund, one of the most treasured collections of pre-Revolutionary Russian jewels. Orlov, in the end, did get a diamond named after him, and a big marble house in St. Petersburg, but he did not, unfortunately, get the girl.

1772

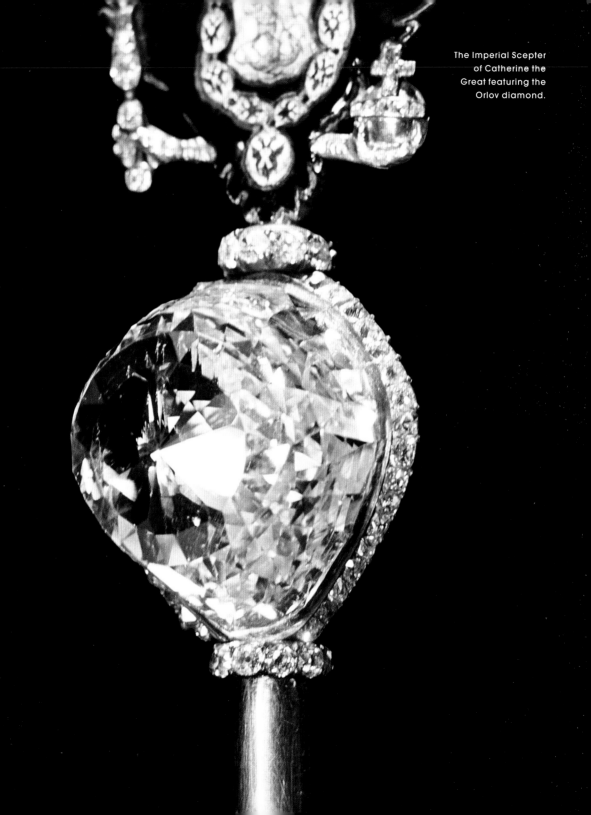

Diamonds at the Revolution

Where to begin with the Affair of the Necklace? The spurned cardinal? The prostitute masquerading as a Queen? Forged letters handed off in Versailles at night? Let's start with smallpox. It's what killed Louis XV in 1774, leaving Madame du Barry without a royal companion and a jeweler with an unpaid bill. Louis XV had commissioned a necklace for his mistress: 650 diamonds in long strands, festooned with bows. But the king died before the necklace was finished—and paid for—Madame du Barry fell out of royal favor, and the jewelers Boehmer and Bassenge started scouting potential clients, chief among them the new Queen. But Marie Antoinette was astutely aware of what buying a necklace like that might do to her already established reputation for extravagance. Enter the trickster Comtesse de la Motte. She knew the jewelers were desperate, the image of the Queen, and the weakness of one Cardinal Louis de Rohan, rejected by the court for unkind words about the Queen's mother, and ready to find a way back in. What better way than to get the diamond necklace the Queen so desperately wanted but was too embarrassed to buy herself? This was de la Motte's ruse. She forged letters from the Queen to the Cardinal, putting into place a deceitful plan. The notes asked the Cardinal to pay for the necklace in return for the Queen's

1785

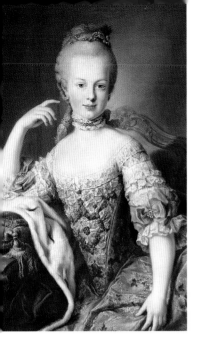

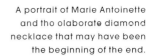

gratitude. A prostitute was hired to impersonate the Queen and meet the Cardinal at night in the gardens of Versailles. He makes a partial payment to the jewelers and trusts the necklace to the Comtesse who promises she will deliver it to the Queen. Instead, the Comtesse sends it to a partner in London, who sells it for parts. When the jewelers come for the next installment and the Cardinal can't quite make the payment, they decide to go straight to the Queen. Marie Antoinette has never seen the necklace, and had never signed any letters to the Cardinal. He is arrested in the Hall of Mirrors. Comtesse de la Motte is imprisoned. But Marie Antoinette, who never did want the diamond behemoth, received the harshest sentence of all. The public turned on their unpopular but, in this case, blameless Queen for her perceived frivolity and for being mixed up in such a sordid affair, and in 1793, a revolution meant Marie Antoinette would never wear a diamond around her neck again. Was it really the jewelry's fault? Even the most by-the-book historians identify the Affair of the Necklace as a key turning point in the life—and death–of the French monarchy.

Why do certain styles reappear at one specific moment in history? The history of cameos does not begin with Napoleon, but the answers to these questions might. The Emperor's thing for cameos—he also established a school for gem carving—likely began with his conquest of Italy. He brought back original examples, and desire for cameo jewelry consumed his empire.

The Cameo in the Crown

At his coronation in 1804 he wore a gold laurel wreath, à la Julius Caesar, before changing to a cameo-studded crown inspired by Charlemagne. The cameos served to remind the public of his successful campaign and also bestowed a sense of history to his brand-new regime. Carved into the stones on his crown were scenes of the achievements of the Roman Empire, reflecting his desire to match its glory. His Empress Joséphine also faced a predicament: how to look like a queen without royal jewels to match. She too turned to cameos to solve the problem. She was crowned with a tiara of cameos as well, new power anointed with symbols of the establishment. But Joséphine's crown does not stay on for long. When she fails to produce

1804

an heir she is banished, and takes the cameos, and her two children from a previous marriage, with her. Her son Eugene is thought to have inherited the cameos.

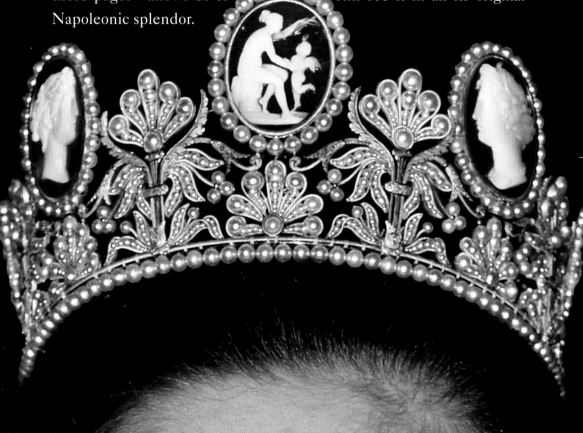

A cameo depicting Napoleon (he was a big fan); and the cameo crown he commissioned for his wife Josephine, now part of the Swedish royal family jewels.

for the crown soon appears in a portrait of his daughter Joséphine, who marries Crown Prince Oscar of Sweden and Norway. It is this union that brings Joséphine's cameo tiara into the Swedish royal family, where it remains—intact and often, worn—today. In 1961 it becomes the official wedding tiara of the Swedish royal family. Had the cameo tiara not migrated to Sweden would it have been sold, as so many other French jewels were when the Third Republic came into power after the fall of Napoleon III? A twist of jewelry fate—there are several documented in these pages—allows us to still see it in all its original Napoleonic splendor.

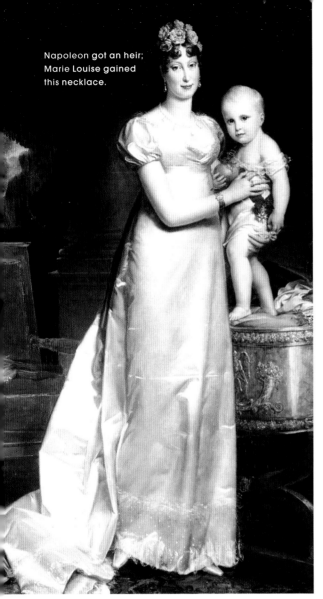

PUSH! Let us talk

now of another jewelry twist of fate. And for this one, let's give thanks to Harry Winston and Marjorie Merriweather Post. We are able to stand in front of a vitrine in the Hall of Minerals and Gems at the Smithsonian Museum in Washington, DC, and experience the glory (234 diamonds worth of glory) of Empress Marie Louise's Napoleon necklace because the great American jeweler and his client— one of jewelry's patron saints—understood that the historical value of preserving the piece in its original form outweighed the monetary rewards of taking it apart and selling the stones separately, as was the common practice. But how did this piece of French history end up in their noble American hands? In 1810 Napoleon divorced Joséphine for failing to produce an heir. He quickly married Marie Louise, a member of the Habsburg dynasty, who promptly gave birth to their son, and was given this necklace in celebration. Yes, this may be the first post-deliv-

ery diamond gift known as a "push present" ever recorded. Luckily, as we have and will continue to witness throughout history, jewelry is easily transported from one country to another. When, for example, Napoleon is exiled to Elba, Marie Louise—and her necklace—instead returned to the comforts and safety of her pre-Napoleon Habsburg life. The diamonds remained with her family, shining and intact (except for two removed in 1847 to shorten the necklace, whereabouts unknown). In

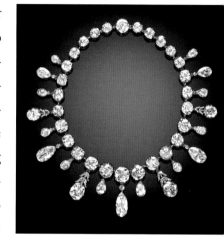

1929 a member of the family dispatched two emissaries to New York to attempt to sell the necklace for $450,000. A tough sell during the Great Depression certainly, but even more difficult when they turn out to be fraudsters abetted by a distantly related and destitute Archduke who endorsed the sale for $60,000, with the grifter couple claiming $53,730 in expenses. The Habsburgs sued, the duo fled, the Archduke was arrested, and the necklace returned. In 1948 the family sold it to a French collector who sold it to Harry Winston. Winston is said to have known that his client Mrs. Post, a devoted collector of important historical pieces, would appreciate the necklace and its legacy in its original form—

and original box!—and that is exactly how he sold it to her. In 1962 Marjorie Merriweather Post donated the piece, as she did other priceless treasures, to the Smithsonian, where it continues to be displayed today.

Examples of highly
collectible Berlin Iron
jewelry, circa 1815.

A War Effort

Quick: You are the Prussian royal family and need to fund the Napoleonic Wars. What do you do? Answer: Ask subjects to donate their silver and gold to support your campaign. Offer them iron pendants and bracelets with an intricately crafted lace pattern in return. Watch as cast-iron jewelry once associated with mourning becomes a symbol of patriotism and loyalty, and then two centuries later, as "Berlin Iron" becomes a collector's item jewelry connoisseurs scour the globe to discover.

1813

A Myth Debunked

A suite of black opal, sapphire, and Demantoid garnet jewelry by Louis Comfort Tiffany.

Can a rumor be written in stone? The history of the opal seems to suggest that it can. And it all started out so well. The ancients believed opals were portenders of hope, they believed they granted the wearer the gift of prophecy, and that they were helpful in matters of eyesight and the hair. And then the plague came, and legend of a mysterious corpse's pal ring that lost its luster made the rounds. There was also

Spanish royal, and his dead wife, and other deceased relatives, all with an opal in common. But those seemed to have been dismissed as old wives' tales, or part of the natural decomposition process, until Sir Walter Scott wrote a novel titled *Anne of Geierstein*, or (and for our purposes a much better title) *The Lady of the Mist*. There is no evidence at all that Sir Walter included the detail of the opal with any malice aforethought. He likely simply thought the stone's magical glow would be most becoming set, as it were, in his enchanted Lady Hermione's hair. The stone is, admittedly, a bit temperamental throughout the novel and a flaring indicator of the Lady's moods. Holy water is finally flung at it to extinguish its powers. The stone loses its radiance as a result, and Lady Hermione her life—the next morning she is reduced to a heap of ashes. Could Sir Walter have known this pivotal scene would establish opals as the reigning bad luck charm in the jewelry kingdom for years to come? Queen Victoria did help the stone's reputation a bit every time she wore one, as did the art nouveau movement's penchant for them, but opals were hit with another unfortunate stroke when nineteenth-century diamond merchants picked up on the superstition and campaigned hard to spread the false legend of the opal. Twenty-first-century jewelers took up the stone's cause and use it often, but are still plagued by the question: "Aren't opals bad luck?"

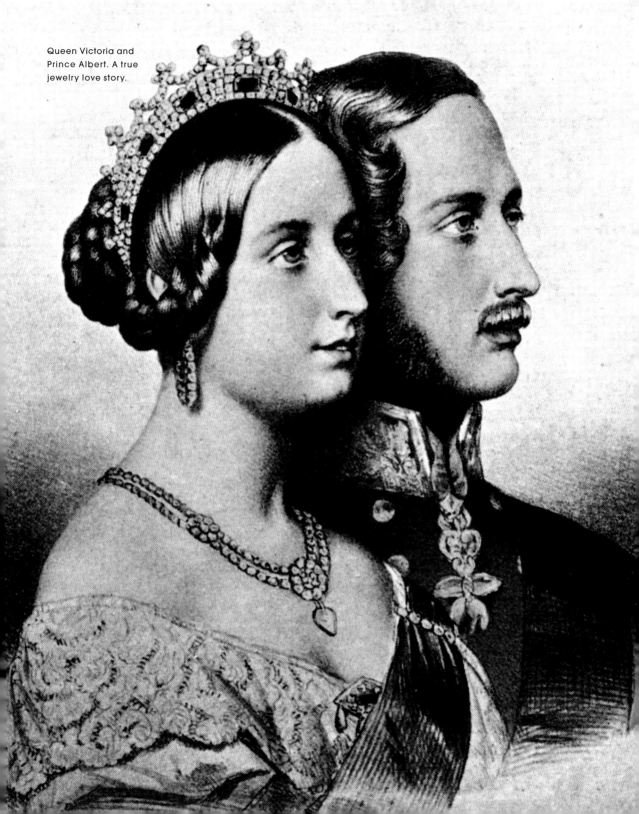

Queen Victoria and Prince Albert. A true jewelry love story.

Queen Victoria reigned over an ever-expanding Empire from 1837 to 1901, a time of great social and industrial transformation in England. She also set jewelry trends. **1839**

Her influence began with her engagement ring from Albert: a serpent with ruby eyes and an emerald (her birthstone). Today when a bride-to-be chooses something other than a diamond, we immediately speak of her "unconventional choice," but the serpent was an ancient symbol of wisdom, commitment, everlasting love—and infinitely more popular than diamonds at the time (as was using birthstones in engagement rings). Receiving an engagement ring was, until the Victorian industrial boom, largely reserved for aristocratic circles, but as prosperity grew in England, so did the demand for jewelry and engagement rings. Many young brides-to-be, thanks to Victoria's popularity, hoped theirs was in the shape of a serpent.

The Original Influencer

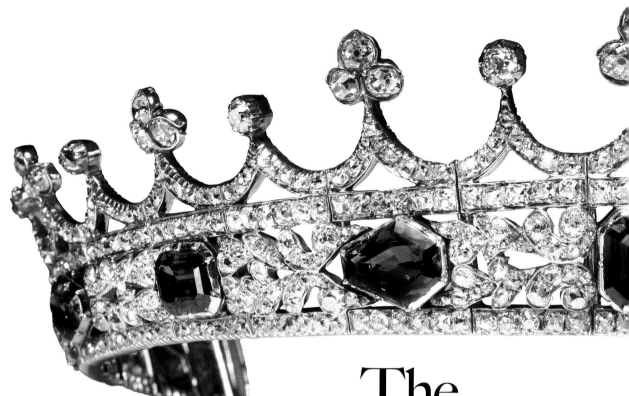

It is certainly beautiful, with eleven sapphires set in gold and diamonds set in silver. But its "associations and place in history" are what led a 2019 initiative to make sure Queen Victoria's coronet stayed in England. The Queen wore it in a portrait by Franz Winterhalter, where it is depicted in an unexpected position, circling her chignon. The coronet is but one piece in a royal collection that inspired experts to cite Victoria as one of the original "influencers."

The Coronet That United England

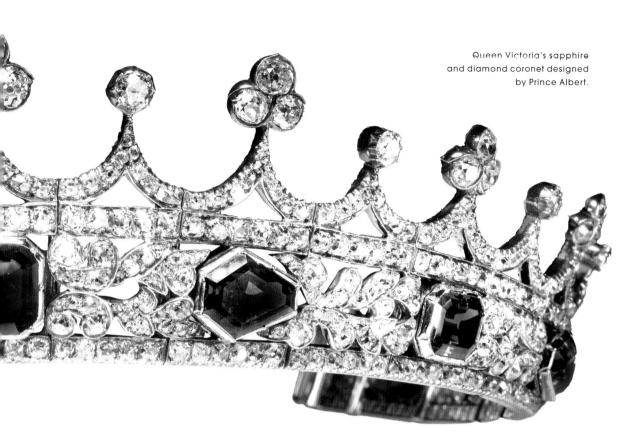

Let us go back to 1840, the year Victoria and Albert were married, the first moments of one of the great love stories. Albert designed the coronet for Victoria, and it is the one she chose to wear atop her widow's cap for the first State Opening of Parliament after Albert's death. This was Victoria's first appearance after Albert's death, and one of the few times she wore colored stones as a widow. Theirs was a true love story; the coronet is a national symbol of their devotion.

1840

The coronet, however historically significant, is a personal, not a Crown, jewel and so when Victoria died it began its path through her descendants. Princess Mary was photographed wearing it, although in a more modern bandeau style, and in 1992 at the wedding of the 7th Earl of Harewood's son, the

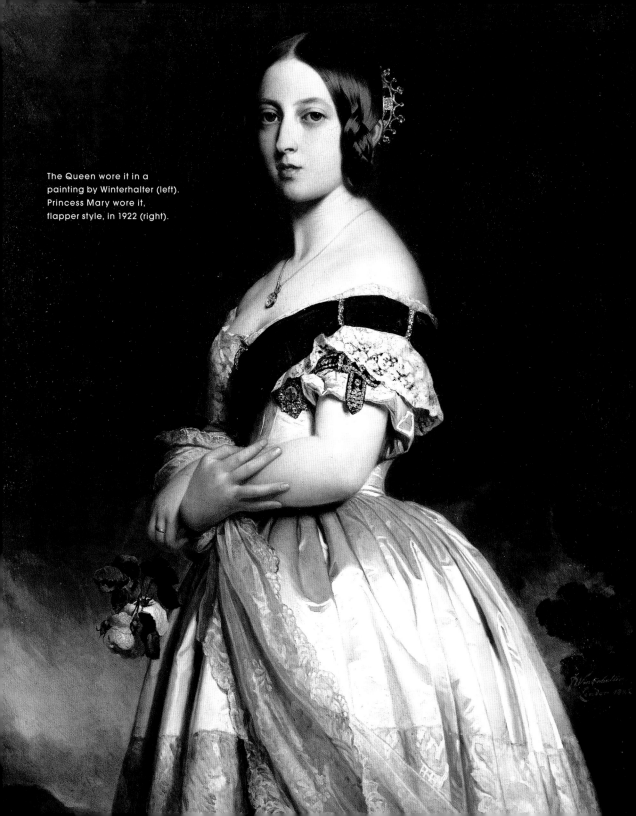

The Queen wore it in a
painting by Winterhalter (left).
Princess Mary wore it,
flapper style, in 1922 (right).

lucky bride wore the coronet. In 1997 the family of the Earl of Hare-
wood loaned the piece to Wartski, the famed London gallery that creat-
ed Charles and Camilla's gold wedding bands. After that, accounts vary.
The coronet was photographed at various events and went on to be

displayed internationally. In
2016, the coronet's sale to a
foreign buyer threatened to
take Queen Victoria's jewel
out of England. A national out-
cry ensued and an Irish billion-
aire named William Bollinger
came to the rescue. It remains
unclear who had sought to sell
it to the foreign buyer. But
thanks to Bollinger—and $6
million—the coronet remains
in England. And Victoria and
Albert's love story—as well as
his exquisite taste in jewelry—
remain proudly on display in
the jewelry galleries of the Vic-
toria & Albert Museum, an in-
stitution that is, in itself, a trib-
ute to them both.

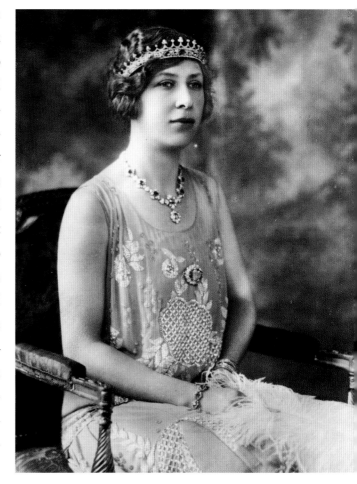

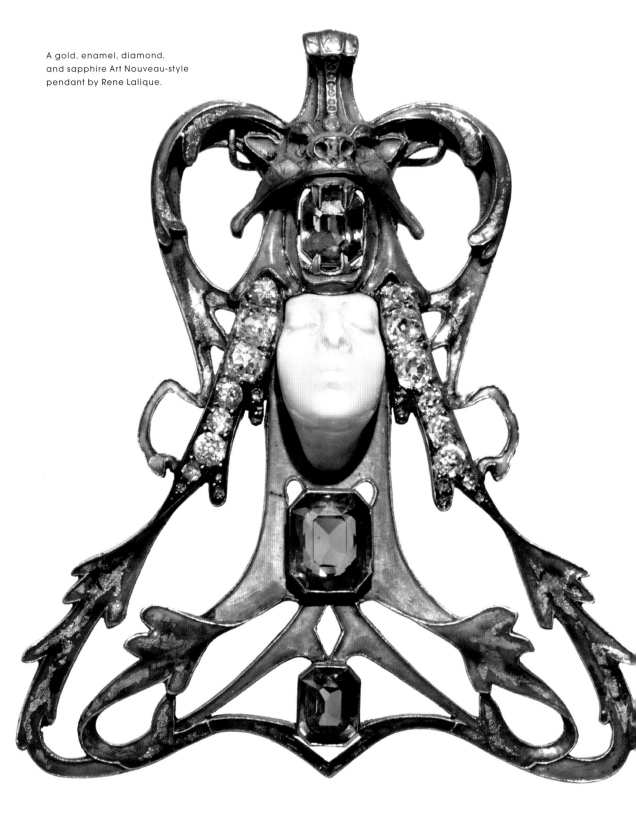

A gold, enamel, diamond,
and sapphire Art Nouveau-style
pendant by Rene Lalique.

Enter Japan

When Commodore Perry sailed into Tokyo harbor to demand Japan enter into trade with the United States, did he have any idea what impact that would have on the future of necklaces? Art nouveau, a brief but influential design movement that began in the late nineteenth century and ended abruptly with the start of the First World War, was represented in all areas of art. It was characterized by a reverence for nature and an embrace of sinuous lines and painterly materials that was undoubtedly created as an antidote to the rapid industrialization of the late nineteenth century, as well as the phenomenon of tossing off old traditions that happens a few times each century. But the Japanese woodblock prints and the images of Japanese gardens and the antique Japanese porcelain that appeared in European galleries and shops after Japan opened to Western trade are also woven throughout art nouveau's aesthetic. Look closely at the colors and flourishes and dimensionality of art nouveau master René Lalique's work and then back at an image from Josiah Conder's *Landscape Gardening in Japan*, first published in 1893, and it's clear that as trade opened, so too, did the corridors of inspiration.

1853

The Emeralds Amongst the Exiles

How does one set of emeralds map the migratory patterns of three exiled queens? Empress Eugénie of France, wife of Napoleon III and the last empress of France, was born into the Spanish aristocracy as Eugénie de Montijo. She had an extraordinary personal jewelry collection, as well as enjoying access to the French crown jewels. She is credited with sparking an international trend with her corsage bow brooch and with her penchant for nature themed jewels: roses, feathers, vine leaves. She also had a thing for emeralds. She received an extraordinary set of the green stone, perhaps as a wedding gift from the Spanish royal family, who had access to the mines of Colombia. Empress Eugénie had them set into a crown, one she took with her into exile in England, where she was warmly welcomed in 1871, having befriended Queen Victoria. Her emeralds are handed down to Victoria's granddaughter (and Eugénie's goddaughter), Princess Victoria Eugenie who in 1906 becomes Queen of Spain. She, like her godmother before her, is forced into exile, and settled in Switzerland in 1931. In 1961 she sells her emeralds, several of which had been reset into a necklace, which is bought by Cartier, who in turn sells the cache

1858

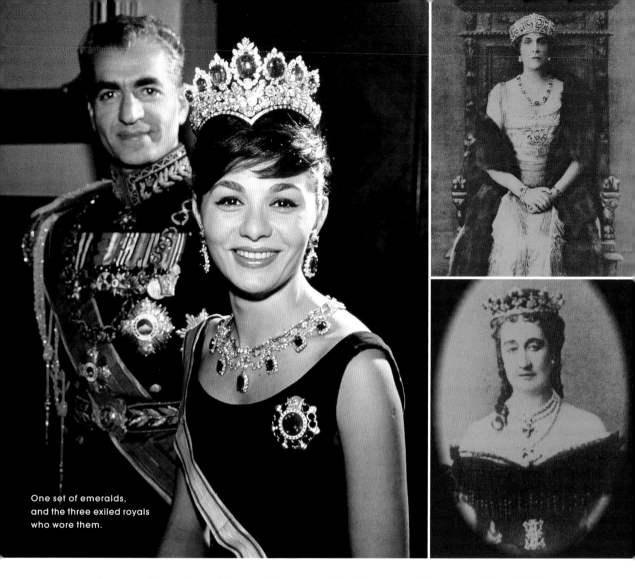

One set of emeralds,
and the three exiled royals
who wore them.

to the royal family of Iran. Empress Farah wears Empress Eugénie's emeralds with a matching emerald and diamond crown to the legendary celebration at Persepolis in 1971, described as the "party of the century." Empress Farah's reign does not last long and in 1979 amidst death threats and revolution, the Iranian royals flee. Their jewels, including the emeralds of another exiled queen, are left behind, and remain in the vaults of the Central Bank of Tehran.

Death Becomes Them

How do jewelry trends begin? The death of Prince Albert in 1861 and the desire for Whitby jet that follows provides an answer. Whitby jet, a black opaque stone formed from fossilized wood, was first mined around 1840 along the northeast coast of England. In 1851 it was shown at the Great Exhibition, organized by Prince Albert, and jewelry designs using the material soon appeared. But it was not until Queen Victoria entered mourning did Whitby jet's reign truly begin. It was the only stone permitted in court after Prince Albert died. We have established Victoria's role as the original jewelry influencer and the movement toward the use of dark-hued materials after Albert's death is further evidence. The trend was translated more widely in the appearance of black glass, dark tortoise-shell, and banded agate in jewelry design. The market for mourning jewelry grew as it also became a way for American Civil War widows to commemorate their lost loved ones. And if we can chart the beginning of a trend, how do we explain its decline? Victoria dies in 1901, signaling the end of a spectacular reign but also the end of England being led by a woman, a beloved one, dressed in mourning jewelry. Whitby jet mines are depleted by the demand and somber black jewels suddenly felt like a relic of a past era. The travel industry was booming, and the richly colored vistas of foreign lands would soon come to life in art nouveau's vividly colored and wildly imaginative motifs.

1861

A mourning ring of enamel and gold commemorating the death of Princess Charlotte. The tradition became a national trend after the passing of Prince Albert.

A Magic Carpet

There are, by most estimations, over a million pearls in the legendary Pearl Carpet of Baroda. The gem-encrusted textile was commissioned by Gaekwar Khande Rao, the Maharaja of Baroda, who ruled between 1856 and 1870. And in that time, the jewels he bought! But do any tell the tale of the magnificence and splendor of his reign the way his pearl carpet does? Perhaps his Baroda Pearl necklace, but let's begin with the rug. In 1906 a *New York Times* reporter called it "the most costly piece of jewelry in the world. In dazzling magnificence, it never has been, or is ever likely to be, excelled." It was not hyperbole. The pearl carpet is a dazzling testament to the priceless treasures born during a flourishing period of trade between India and the Middle East. Pearls found their way into the collections of the Indian elite, a group also mightily courted by the ruling jewelry houses of Europe at the time. The pearls dis-

1865

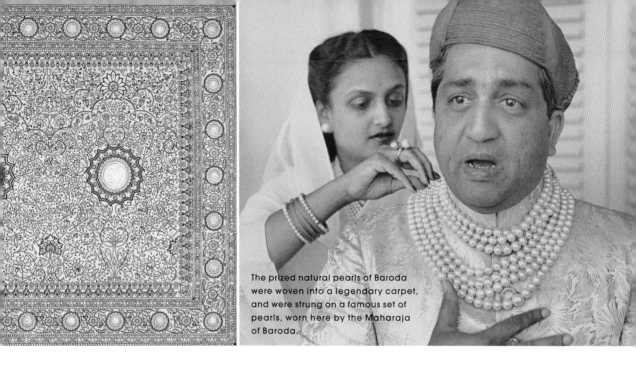

The prized natural pearls of Baroda were woven into a legendary carpet, and were strung on a famous set of pearls, worn here by the Maharaja of Baroda.

covered in the Gulf were known as Basra pearls. They were simply the best, and because of that, between the 1850s and into the early twentieth century, they were all the maharajas wanted. That the *New York Times* noted the impossibility of recreating a carpet of so many Basra pearls would prove prophetic. The wonder of this pearl carpet is of course in its craftsmanship but also in the absolute truth that that it could not, for all the money in the world, ever be recreated. The Pearl Carpet of Baroda is made of natural pearls, actual treasures harvested from the sea, a process that has been impacted so drastically by changes in its ecosystem that it almost never anymore occurs, making natural pearls largely extinct. One can now visit the Pearl Carpet of Baroda at the National Museum of Qatar, but obtaining natural pearls of your own requires a maharaja's treasury: two strands of the original seven from the Baroda Pearl necklace sold at Christies in 2007 for a record price of $7.1 million. And due to the laws of supply and demand, prices for natural pearls, when they can be found at all, continue to climb.

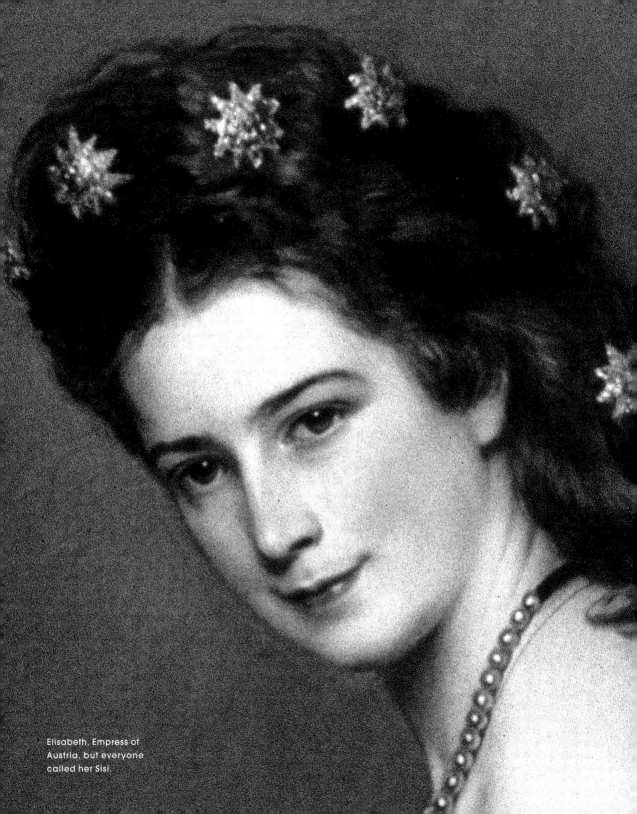

Elisabeth, Empress of Austria, but everyone called her Sisi.

Signature, Please

It's unlikely the term personal brand was in the cultural lexicon of nineteenth century Austria, but Elisabeth of Bavaria, Empress of Austria and Queen of Hungary (everyone called her Empress Sisi) created hers when she bought twenty-seven diamond and pearl stars from the imperial jeweler Köchert and wove them through her trademark waist-length chestnut hair for a portrait by Franz Xaver Winterhalter. Sisi maintained the look that came to define her for several public appearances and formal balls and set a trend or glittering stars and hair jewelry in royal circles. The Empress, also known for her strict diet and exercise routine, small anchor tattoo, love of cigarettes, and complicated relationship with the press that hounded her, grew tired of the stars and legend has it she gave several away to family and her ladies-in-waiting. Those that remain are on display in the museum devoted to her in Vienna, though one star was stolen from a vitrine in 1998 and replaced with a copy. The real thing was discovered in Winnipeg in 2007 and Sisi's star returned home.

18

Diamonds are found in the
Africa. A white diamond

67

Kimberley Mines of South
bracelet boom ensues.

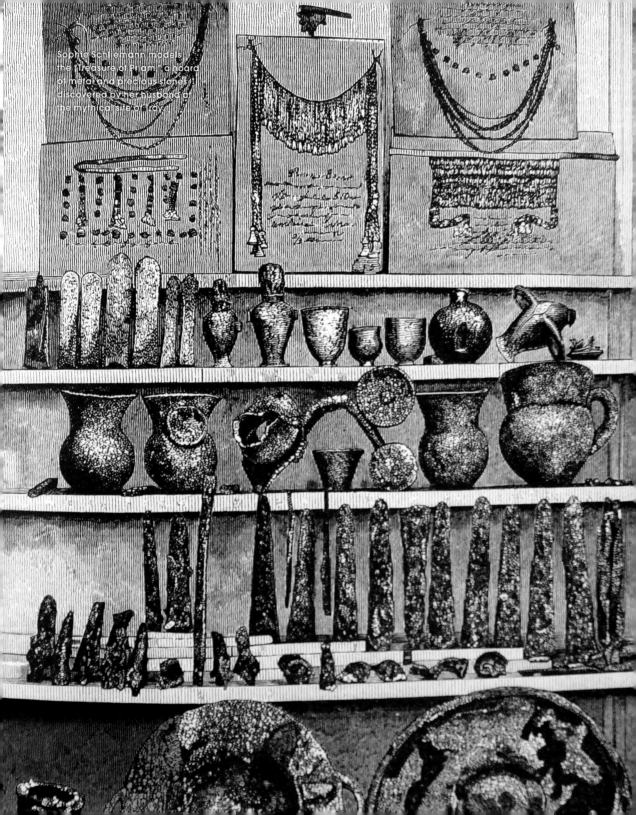

Sophie Schliemann models
the 'Treasure of Priam', a hoard
of metal and precious stones
discovered by her husband at
the mythical site of Troy

A Battle for Gold

It has always been a treasure marked by conflict. No one can definitively claim whom it actually belonged to, but now we know where it is. Germany's Heinrich Schliemann was determined the world believe the copper shields and gold diadems and rings he discovered in an ancient site in modern-day Turkey were the spoils of the Trojan war, the long-hidden loot of Priam. Had he actually discovered Troy? Had the gold belonged to Priam? Questions remain, as does his discovery, now in Moscow's Pushkin Museum. But how did it get there from where it started, in the ground in an Ottoman-controlled area? Jewelry's ability to be easily transported can work in its favor—it can, in circumstances of forced exile, be pinned to a slip to escape notice—but it also means it can be quickly taken, and can disappear fast. After some tense negotiations with the Ottoman government, Schliemann placed Priam's Treasure into the Berlin museum system where it was displayed until World War II. It was then stashed in a vault under the Berlin Zoo, where it was discovered by the Soviets, who took it home. It was all but erased from history until 1993 when it was exhibited at the Pushkin. As it began, a reminder of a legendary Homeric battle, Priam's Treasure remains a matter of contention between international powers. And the war over these treasures of Troy rages on.

1873

George Kunz, Tiffany executive and mineralogist who named several of the stones on the chart here.

1876

What might we have missed if George F. Kunz had not sold that rare tourmaline to Charles Lewis Tiffany? We would not have seen color—Montana sapphires and Russian demantoid green garnets and Utah garnets— enter a diamond-dominated jewelry world as it did after he joined Tiffany & Co. as its chief stone expert. We would not have known kunzite or morganite, stones he discovered and named. We would not have on public view the priceless collection of American magnate J.P. Morgan, a collection curated by Kunz and donated to New York's American Museum of Natural History in 1913. We would not have the carat as a unit of measuring precious gems, or the rare volumes of jewelry research and writings he donated to the U.S. Geological Survey Library. We would not have discovered a long-forgotten album of the Russian Crown Jewels published in 1922. All thanks to that one exchange of that one rare tourmaline and one man named George.

Meet a Man Named George

Aquamarine
Brazil

Aquamarine, green
Brazil

Morganite (rose beryl)
Madagascar

Kunzite (var. of spodumene)
California

Cat's-eye
(chrysoberyl)
Ceylon

Alexandrite
Ceylon

Star sapphire
Ceylon

Starlite (blue zircon)
Siam

Zircon, brown
Ceylon

Zircon, green
Ceylon

Alexandrite
by artificial light
Ural Mountains

Peridot (olivine chrysolite)
Egypt

Garnet
India

Hyacinth hessonite
(variety of garnet)
Ceylon

Tourmalin, green
Paris, Maine

Tourmalin, red
(rubellite)
California

Topaz, wine-yellow
Brazil

Topaz, pink
Brazil

Topaz, white
Brazil

Topaz, quartz variety
Brazil

Amethyst
Uruguay

Jade
(jadeite variety)
Burma

Opal, black
Queensland

Opal, precious
New South Wales

Fire-opal
Mexico

Moonstone
Ceylon

Turquoise
Persia

GEMS AND PRECIOUS STONES

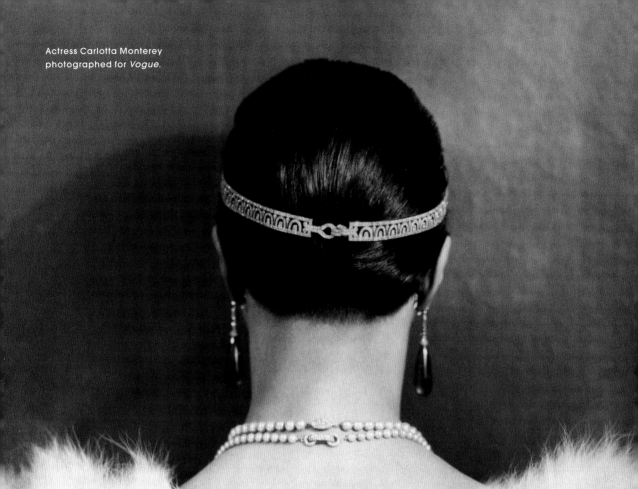

Actress Carlotta Monterey photographed for *Vogue*.

The Necklace as a Plot Point

High school teachers will tell you "The Necklace" is
about distorted realities and simmering class tensions,
and they will use it to teach irony, but really, this short

1884

story by Guy de Maupassant is about the power of jewelry. You remember it, don't you? Madame Loisel is born into middle class circumstances
"by an error of fate," and dreams of one big night out. Her husband buys
her a ball gown but, alas, not the jewels to go with it. She depends on the
kindness, and the vault, of her old friend Madame Forestier. Madame
Forestier invites her to try some things on: "First she saw some bracelets, then a pearl necklace, then a gold Venetian cross set with precious
stones, of exquisite craftsmanship. . . . Suddenly she discovered, in a
black satin box, a superb diamond necklace, and her heart began to beat
with uncontrolled desire. Her hands trembled as she took it." Madame
Loisel wears the necklace to the ball, then wakes from her Cinderella
moment realizing the necklace is no longer around her neck. She and her
husband buy a similar necklace for 36,000 francs to replace it and spend
the next ten years working to pay the debt. Then one day, Madame Loisel, haggard from years of work, runs into her old friend. Truths are revealed. "You say that you bought a diamond necklace to replace mine?"
asks Madame Forestier. "Yes; you didn't notice then? They were very
similar," confesses Madame Loisel. Madame Fore\stier, deeply moved,
takes her hands. "Oh, my poor Mathilde! Mine was an imitation! It was
worth five hundred francs at most . . . !" Alternative thesis for term paper?
Beware: jewels, if you let them, can change your life.

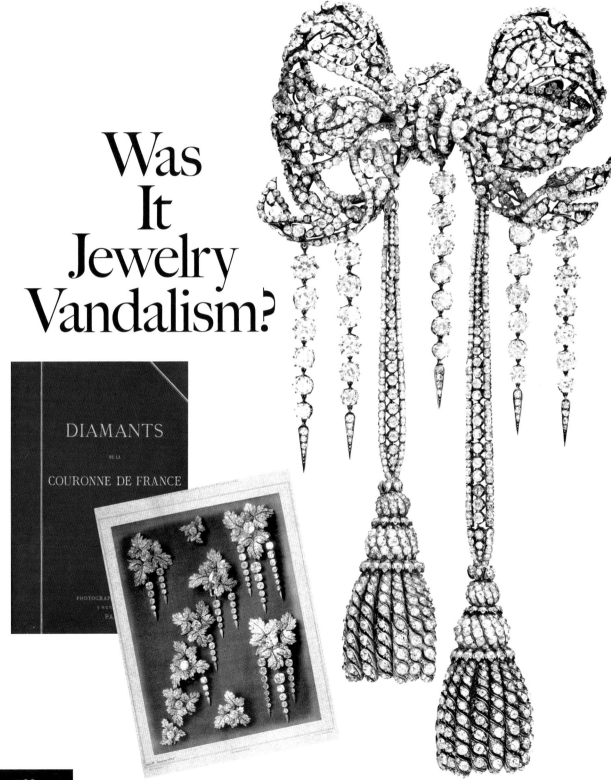

Was It Jewelry Vandalism?

DIAMANTS
DE LA
COURONNE DE FRANCE

PHOTOGRAP
9 RUE
PA

The Empress Eugenie brooch
and other French Crown Jewels
sold at auction.

The sale of the French Crown Jewels occurred in May 1887. After Napoleon III's defeat in 1870, the Second Empire was overthrown and the government began to strip royal crowns of their most valuable and historic stones both as a symbol and to sell them off for cash, arbitrarily keeping some to display in Paris museums. Some point to the sales as some of history's greatest jewelry tragedies; others describe them outright as "historical vandalism"; one of the most impressive collections the world had ever seen, taken apart and sent out freely around the world. Tiffany & Co. famously bought twenty-four of the sixty-nine lots to satisfy the appetites of Gilded Age heiresses for anything with a European royal provenance. Carl Fabergé bought the La Regente pearl, which he then sold to a ruling family of famous collectors in Russia. Louis XIV's eighteen Mazarin diamonds from India's famed Golconda mine were also dispersed.

One turned up at Christie's in 2017 and was sold for $15 million. Though some are now on display at the Louvre—including Empress Eugénie's bow brooch shown here, sold at the initial sale and first acquired by Mrs. Caroline Astor, and now back home through a private sale via Christies—and others occasionally appear at auction, many of the French Crown Jewels stones and pieces have never been recovered. Their fate is one of jewelry's great and enduring mysteries. But as one person pointed out to me, the upside to all this is that some very lucky jewelry collectors are likely walking around wearing French royal emeralds and diamonds without even knowing it.

1887

Culture War

Nature giveth us the jewel. And Nature also taketh it away. Witness, please, the case of the pearl. Their existence is a fluke of nature; sand or a fragment of a shell float into an oyster, and to protect itself, the oyster secretes thousands of coats of nacre that form a pearl. This is the process that forms what we now call a natural pearl, the kind that occur without any human interference, forming organically within the mollusk. For centuries, the most prized natural pearls were from the Persian Gulf, discovered by teams of divers who called them "tears of mermaids." Pearls became the jewel most sought after by royals and aristocrats and all those who wanted to adorn themselves with a jewel symbolizing rarity, taste, and power. But by the early twentieth century, the supply of natural pearls sharply declined. Divers had become intrigued by a booming oil industry, and the allure of black gold replaced the desire to retrieve tears of mermaids. The oil industry also polluted waters and altered the ecosystem, and all but destroyed the oyster population. Meanwhile, cultured pearls, also beautiful and not as costly, entered the market. After years of experimentation, Kokichi Mikimoto pioneered a process whereby a bead is inserted into the oyster, and the layers of nacre form around the bead, mirroring the natural process. As demand exceeded the supply of natural pearls, the cultured variety satisfied desire. A strand of cultured pearls developed into a style icon, while a string of the natural is jewelry holy grail.

1893

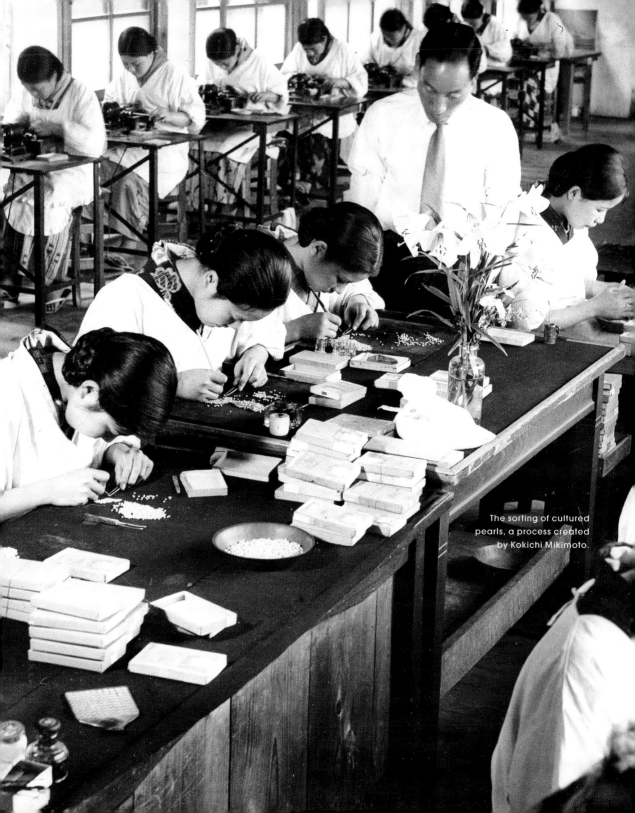

The sorting of cultured pearls, a process created by Kokichi Mikimoto.

1893

The Place Vendome,
Paris.

If you build it, as they say, they will come. Frédéric Boucheron was considered a maverick when he opened his jewelry store on Paris's Place Vendôme. Five years later, Georges Ritz opened a hotel across the square and Boucheron looked like a real estate psychic. Ritz Hotel guests found the stroll across the Place

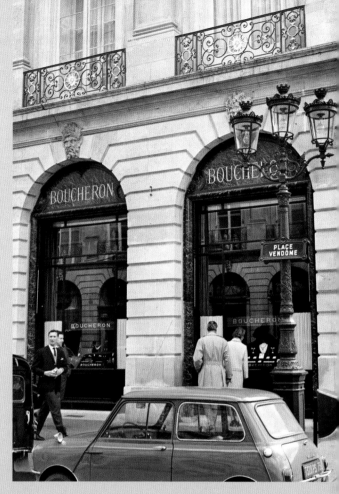

Vendôme to try on Boucheron's revolutionary diamond question mark necklaces very convenient indeed. The Place Vendôme is now one of the great jewelry cross-

Location
Location
Location

roads of the world—Van Cleef & Arpels, Alexandre Reza, Chaumet, Chanel, Lorenz Baumer, Louis Vuitton, Chopard—but it began with one.

1911

There had been colored stone pieces by Cartier before brother Jacques set off for India in 1911, but it was this voyage, to witness the coronation of King George as Emperor of India, that introduced the Cartiers to their carved stone techniques. (This trip also introduced Jacques to the Maharajas for whom Cartier would create some of the most iconic jewels in history.) The impact of this trip is evident in designs that come to be known as "Tutti Frutti." Appearing in the early 1920s, these designs were marked by a combination of sapphires, rubies, and emeralds, and by motifs that included leaves, blossoms, and berries. They distinguished themselves from the whimsical bows that had dominated jewelry until then, and also stood apart from the strict geometry of art deco. They were bold pieces worn by bold women, like sewing machine heiress Daisy Fellowes, whose 1936 *Collier Hindou* of multi-colored carved gemstones was immortalized in a portrait of her by Cecil Beaton.

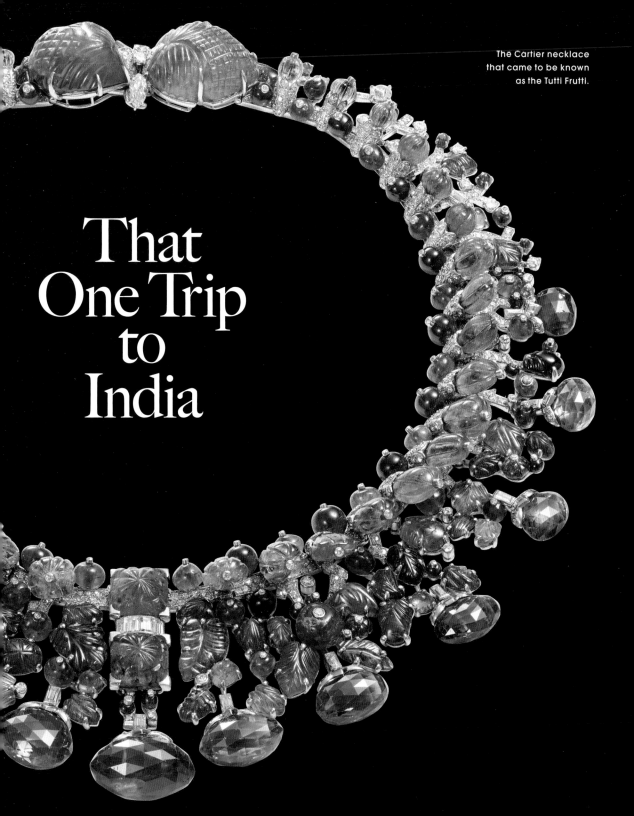

That
One Trip
to
India

What Stone Are You?

It may have ties to Aaron and his bejeweled Biblical breastplate (see The Book of Exodus and the twelve gemstones Aaron used to communicate with God) but the real reason July is ruby and October is opal and February is amethyst is simple: marketing. The idea of birthstones was created by the American National Retail Jeweler's Association. So if you are born in April, we have got a diamond to sell you.

1912

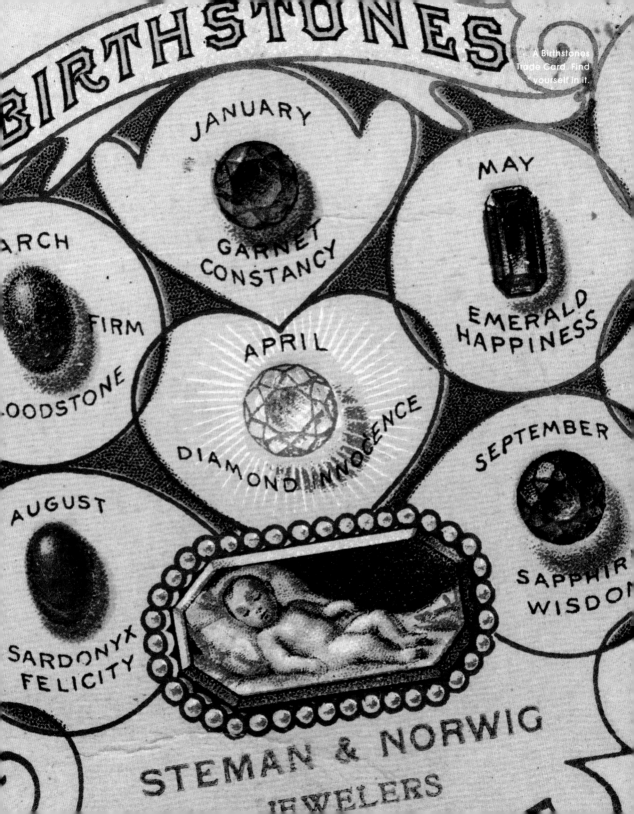

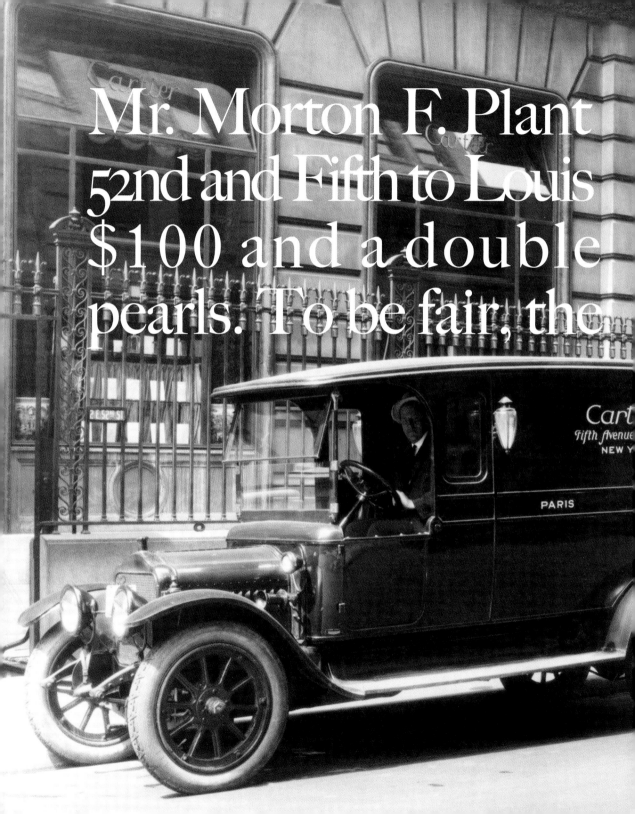

Mr. Morton F. Plant
52nd and Fifth to Louis
$100 and a double
pearls. To be fair, the

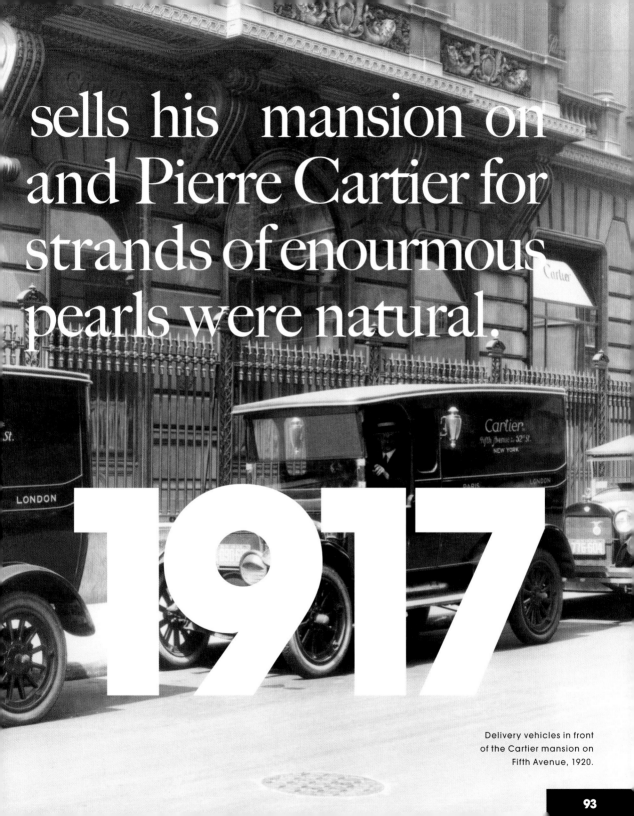

sells his mansion on and Pierre Cartier for strands of enourmous pearls were natural.

1917

Delivery vehicles in front
of the Cartier mansion on
Fifth Avenue, 1920.

The mystery of the Romanov jewels
began soon after the family's execution.
Are answers in the catalogues (known
as the Fersman editions)?

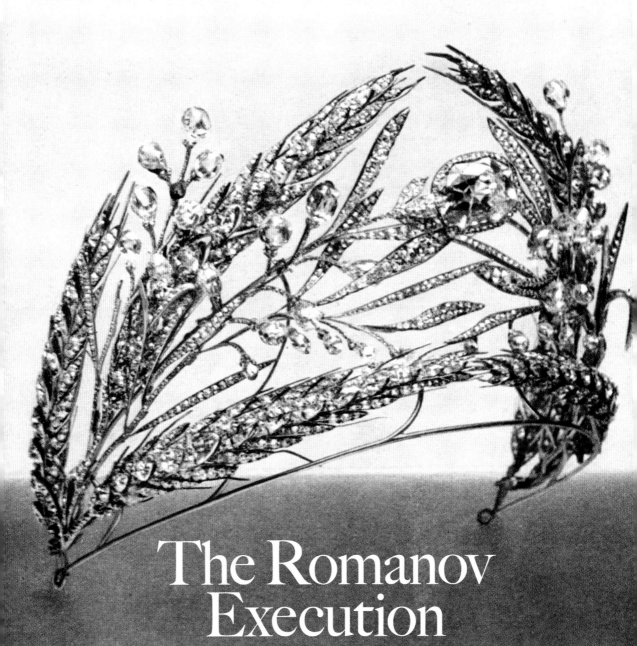

The Romanov Execution

1918

The whereabouts of their jewelry remains an enduring mystery. Which pieces made it out of the revolution and into Europe intact? Which were pulled apart by the government and sold as stones? This remains a developing story. The surest sign of the missing treasures comes to us in a catalogue is also a mystery. In 1925, a four-book set, titled *Russia's Treasure of Diamonds and Precious Stones*, was published by The People's Commissariat of Finances, in French, Russian, English, and German. The Gemological Institute of America (GIA) recently uploaded a version on its website. The motive for the original catalogues is thought to have been an enticement to lure wealthy foreign buyers before a sale, but it was certainly also an opportunity to repudiate rumors that the best stuff had left the country through secret missions. The 1925 catalogue, a carefully documented inventory of the treasures, announced they were all still there. And then, not long after publication, most copies disappeared. Too much compromising information? The Fersman edition catalogues, named after the scientist who oversaw their creation, remain a holy grail of jewelry scholarship. The full scope

of the legendary Romanov collection is documented, and the fate of so many of the pieces shown within lead the reader down the rabbit hole that is Russian history. The catalogues themselves are widely considered to be the most complete inventory of the Russian Imperial jewelry collection. That statement, however, comes cloaked in caveats. A single copy of what appears to be the prototype of these Fersman catalogues, created in 1922, and now the property of the United States Geological

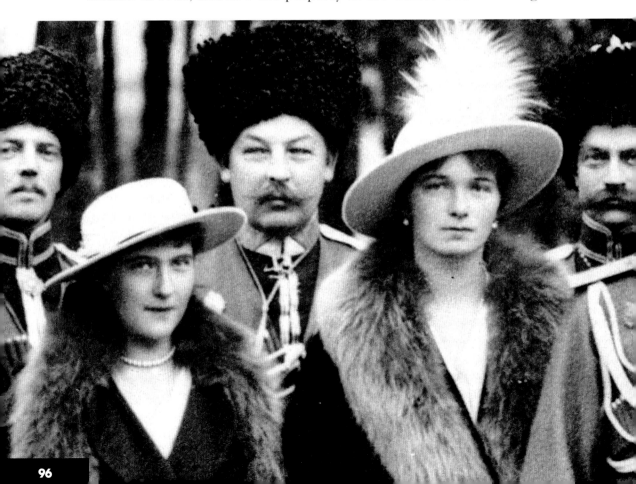

Survey library in Virginia, contains images of a sapphire tiara, a sapphire bracelet, an emerald necklace and a bow-shaped brooch that are missing from the 1925 inventory. The sapphire brooch was sold at auction in 1927; the whereabouts of the others remain unknown. Select pieces from the Russian Diamond Fund are on display at the Kremlin in Moscow—some of them, anyway. And so the search for the lost jewels of the Romanovs goes on.

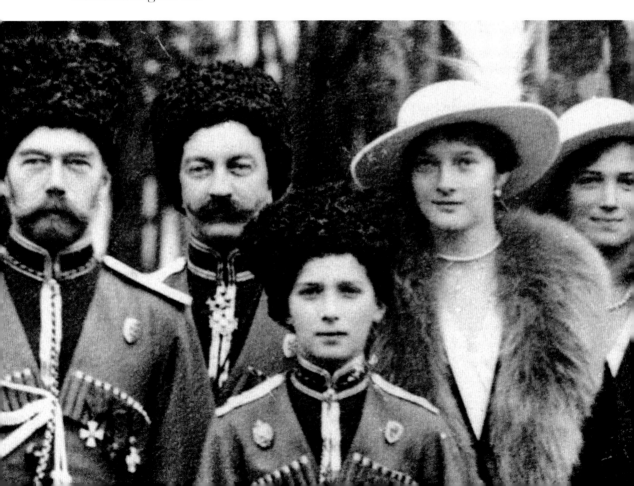

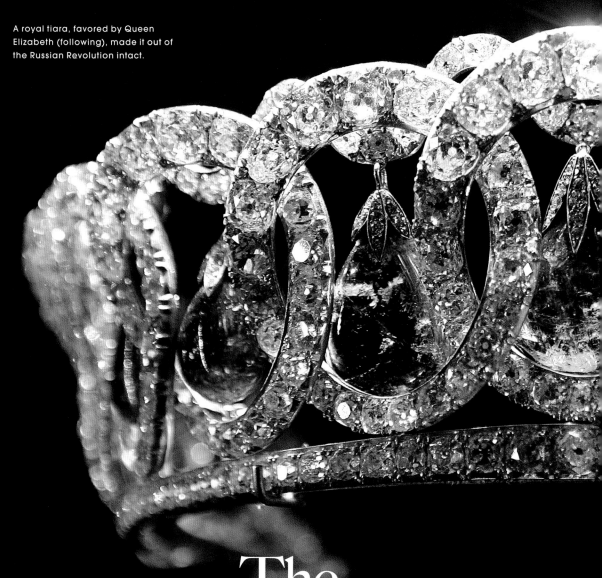

A royal tiara, favored by Queen
Elizabeth (following), made it out of
the Russian Revolution intact.

The
Vladimir Tiara's
Great Escape

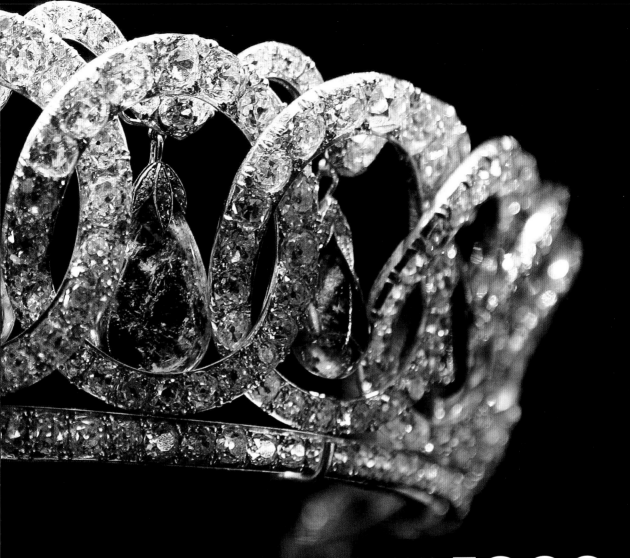

When is jewelry history like a James Bond movie? Often, it's when Russian royals are involved. This diamond-and-pearl tiara was commissioned by Grand **1920** Duchess Vladimir from the Romanov court jeweler Bolin. The Grand Duchess, born Marie of Mecklenburg-Schwerin, joined the Romanov dynasty in 1874 when she married Grand Duke Vladimir Alexandrovich

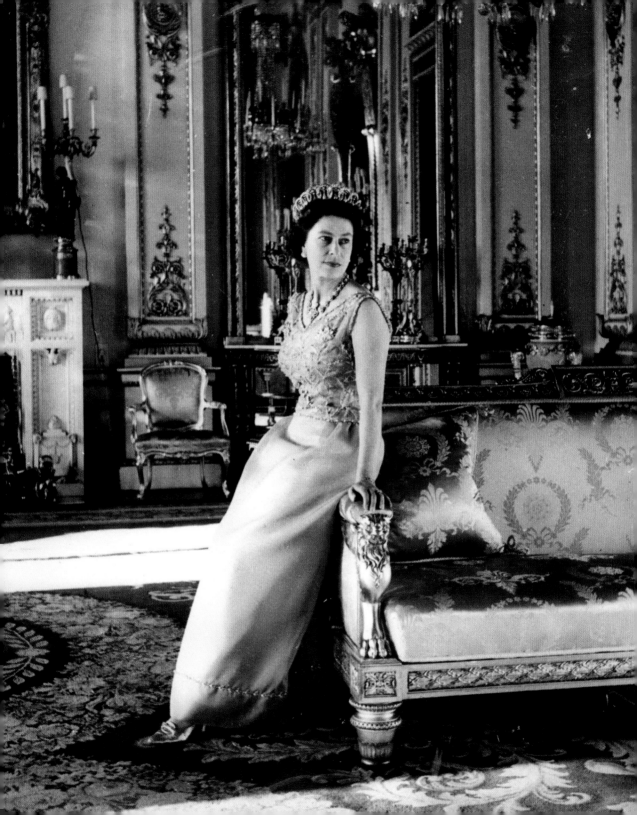

of Russia, uncle to the doomed last Romanov Emperor, Nicholas II. She established a grand court at St. Petersburg's Vladimir Palace, with a jewelry collection to match. Upon receiving news of the revolution, she left St. Petersburg with only a few "daytime jewels and strings of pearls" and hid the real treasures in a secret compartment in the Vladimir Palace. She remained in the countryside until February 1920, when she fled to Venice, the last Romanov to leave Russian soil. Her jewels, however, had gotten out before she did. In an operation worthy of a thriller, a British officer snuck into the Vladimir Palace dressed as a worker (though one version states it was as an old woman) and stashed all the hidden jewels in his bags (in the old-woman version, some were sewn into a bonnet). The jewels made it safely out of Russia and to London, where her son, Grand Duke Boris, was living in exile.

After Grand Duchess Vladimir's death, her family began to auction her jewels to support themselves. The Vladimir tiara had been damaged a bit during its voyage, and so when it was sold to England's Queen Mary (Queen Elizabeth's grandmother), she took the opportunity to make the tiara more versatile.

Fifteen emeralds that once belonged to Mary's mother Mary Adelaide (the original Duchess of Cambridge) were added, along with a mechanism that allowed them to be interchanged with the original pearls. It remains one of Queen Elizabeth's favorites (she favors it with the pearl drops for visits to the Vatican), or the alternate emerald drops (for a visit with the President of Ireland), or sometimes with no drops at all.

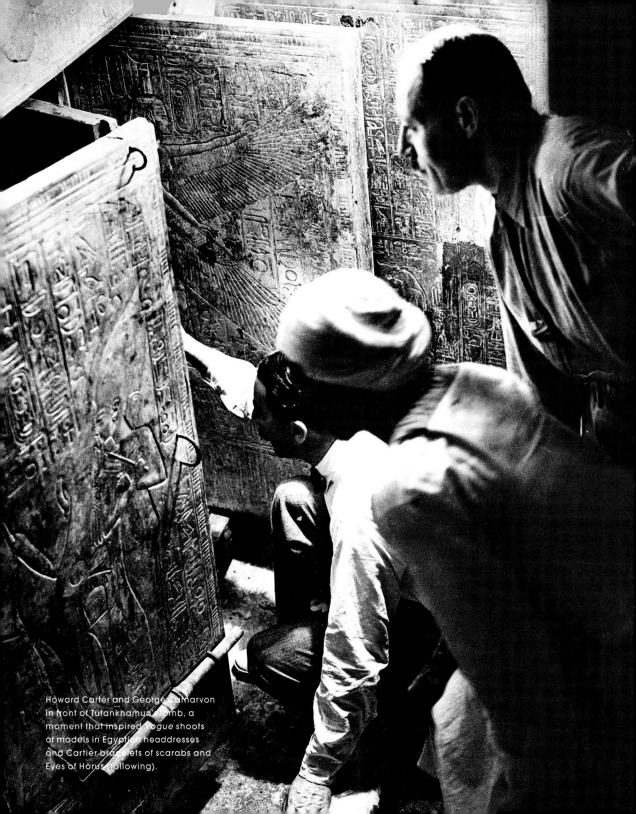

Howard Carter and George Carnarvon in front of Tutankhamun's tomb, a moment that inspired *Vogue* shoots of models in Egyptian headdresses and Cartier bracelets of scarabs and Eyes of Horus (following).

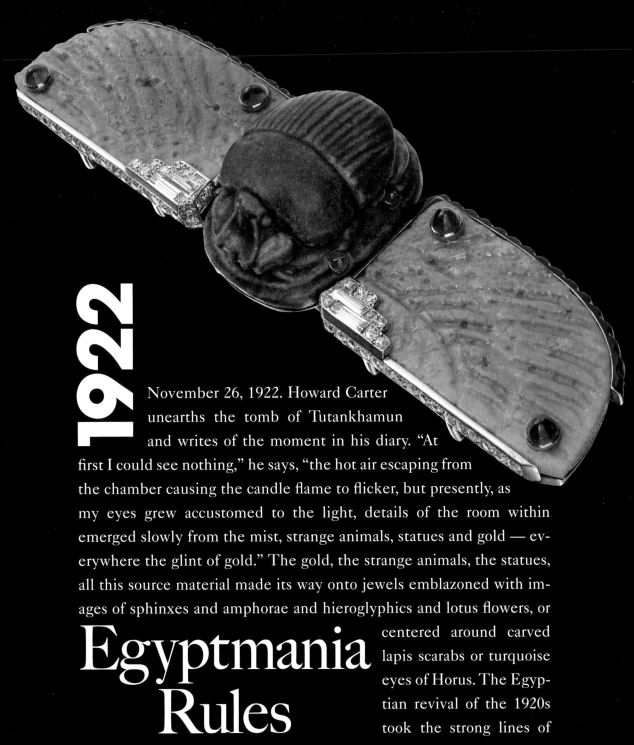

1922

November 26, 1922. Howard Carter unearths the tomb of Tutankhamun and writes of the moment in his diary. "At first I could see nothing," he says, "the hot air escaping from the chamber causing the candle flame to flicker, but presently, as my eyes grew accustomed to the light, details of the room within emerged slowly from the mist, strange animals, statues and gold — everywhere the glint of gold." The gold, the strange animals, the statues, all this source material made its way onto jewels emblazoned with images of sphinxes and amphorae and hieroglyphics and lotus flowers, or centered around carved lapis scarabs or turquoise eyes of Horus. The Egyptian revival of the 1920s took the strong lines of

Egyptmania
Rules

the art deco period of which it was a part of, and worked within it while adding traditional Egyptian iconography. This was not the first time Egyptomania had spread through the jewelry world: Earlier Egyptian Revival periods can be seen in jewelry created after Napoleon's 1798 Egyptian campaign, and again in post Civil War America, where travel and a desire to learn more about foreign lands boomed. Some also cite the first performance of Verdi's opera Aida in America in 1871 as an inspiration. But those pieces are, unlike their art deco descendants, are often rendered in gold. If you see a diamond and platinum bracelet with a coral and onyx phoenix rising, you can confidently identify it as having been created after Howard Carter opened that last wall of the tomb and gazed upon the Boy King.

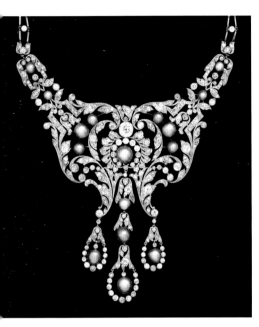

As much as history hinges on what actually happened, it is equally indebted to what might have been. A necklace of diamonds and natural pearls is occasionally exhibited at the Metropolitan Museum of Art. The style is typical of the early twentieth century: diamonds set in cascading garlands and accented with natural pearls. The name on the plaque, less known. Yet for the Gilded Age elite, New York's Dreicer & Company signified great status. The family company is credited with introducing natural pearls to the American market, and created pieces for royalty, heiresses, and actresses like Sarah Bernhardt. Owning a piece from Dreicer's Fifth Avenue store was a symbol that yes, you knew what was best. In the early 1920s, after a series of family deaths and tragedies, Dreicer shut their doors. But not before Cartier bought their inventory for $2.5 million. The history of jewelry is filled with missing chapters of lost masters. What was, and might have still been a household name, is a mysterious credit on a museum plaque.

And What of Lost Masters?

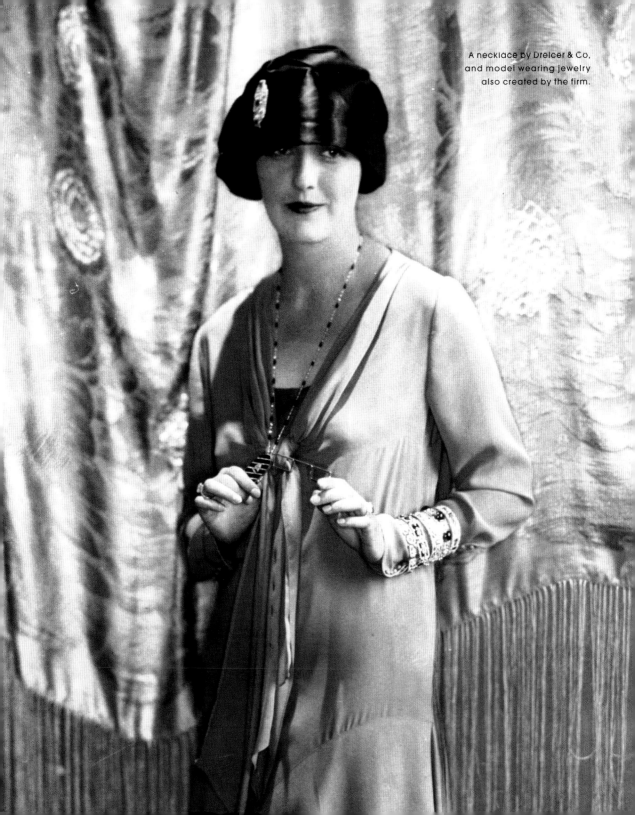

A necklace by Dreicer & Co,
and model wearing jewelry
also created by the firm.

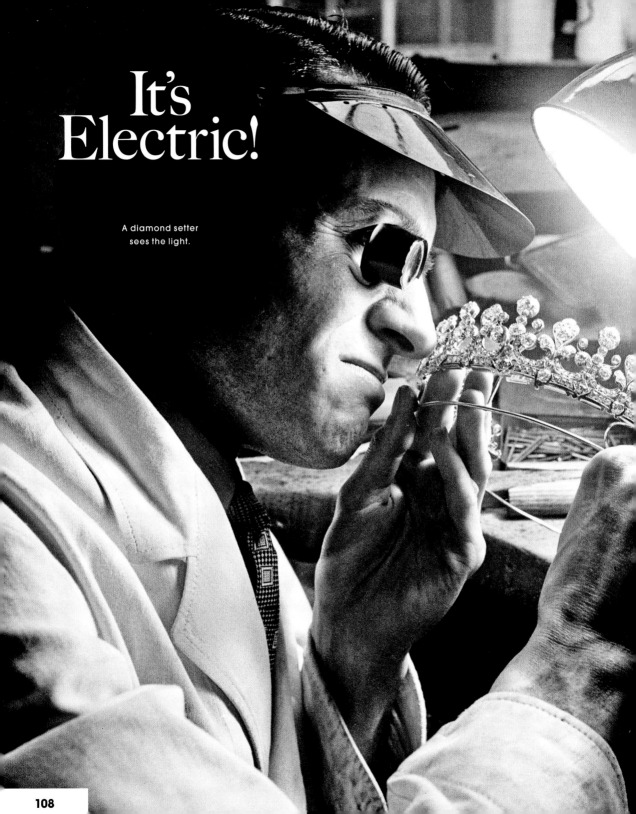

It's Electric!

A diamond setter
sees the light.

Jewelry, it's important to note as we examine its role in history, is an art form created to be worn. Where it is worn, and under what circumstances, impacts its design as much as foreign influence, new trade routes, natural resources, and twists of fate. Thus, the jewelry you wore under dim gas lighting was not the same jewelry that sparkled under the new electric bulbs now present in most houses and at dinner parties. Gaslight jewelry needed to be set with many small diamonds for a twinkling effect, but modern lighting allowed more unusual cuts. Jewelers began to experiment with stones and cuts that did not have to work as hard to sparkle but provided maximum impact. Carved-stone necklaces in the Indian style and wildly colorful cabochon cut creations began to come to light.

1924

1925

They first called it style moderne. The term "art deco" was born after the World's Fair in Paris known as Exposition Internationale des Arts Décoratifs et Industriels Modernes. The name stuck. As did the taste for the streamlined jewelry presented there. "Art deco jewels remain one of the strongest and most collectible sectors of the jewelry market," said Frank Everett of Sotheby's after a 2019 record-breaking sale of a Cartier art deco sapphire and diamond bracelet. "Season after season we see exceptional pieces from the 1920s and 1930s command top prices." What is it about art deco? "This jewelry represents the ultimate attention to detail in terms of design, materials, and craftsmanship, and will always harken back to that glamorous period 'between the wars' when lifestyles called for dressing up and wearing lots of jewelry every day," says Everett. There is glamour for sure, and exquisite artistry, but the jewelry created during this time, a period of design some mark as beginning as early as 1915 but one that reached its height after World War I and continued into the

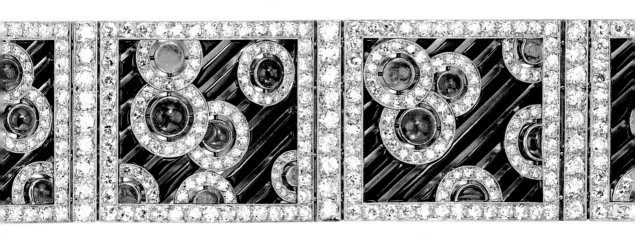

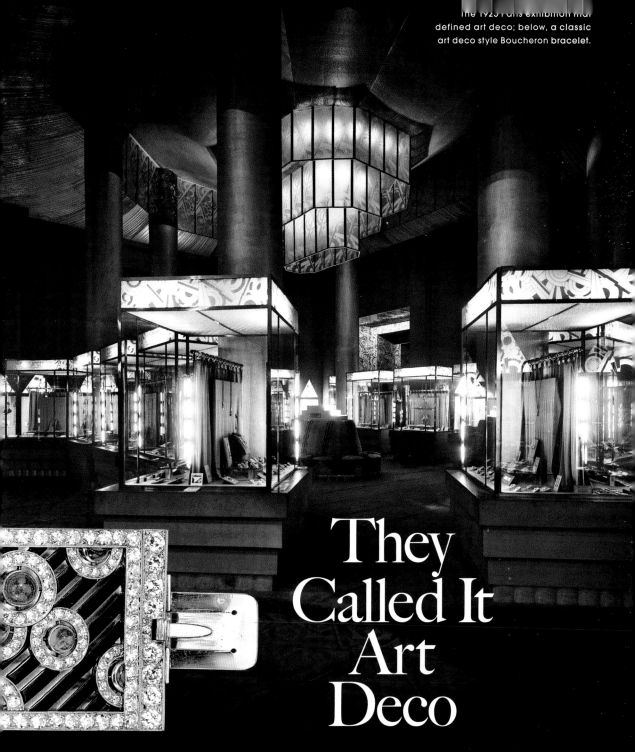

They Called It Art Deco

1930s, also tells the tale of a society breaking with the past and racing towards the future. The geometric lines of art deco were a rejection of the grandly romantic bows and garlands of the belle époque style and the wild naturalism of art nouveau. This was the jewelry inspired by a world fascinated by the rapid rise of machines as well as by the public's newfound ability to travel to exotic locations. The war brought women a sense of independence as they entered the workforce, and just as the fashion of the Roaring Twenties expressed that daring, newfound freedom, so did the jewels of the time. "While designers came from diverse backgrounds, they all held the same ideal: to make a clean break from the past, draw inspiration from everyday life, and rid the decorative arts of useless ornamentation," Laurence Mouillefarine, a historian of the art deco period said. There is a fearlessness to art deco jewels, in the bold sculptural shapes and in the materials. The use of onyx and jade and rock crystal and lapis and coral and colored carved gemstones reflect a culture and a creativity unbound. The consistent allure of the pieces from this period can be explained in their aesthetic beauty surely, but their qualities of boldness and optimism for the future is equally powerful. Even without knowing it, one can sense they are wearing an artifact of a revolution.

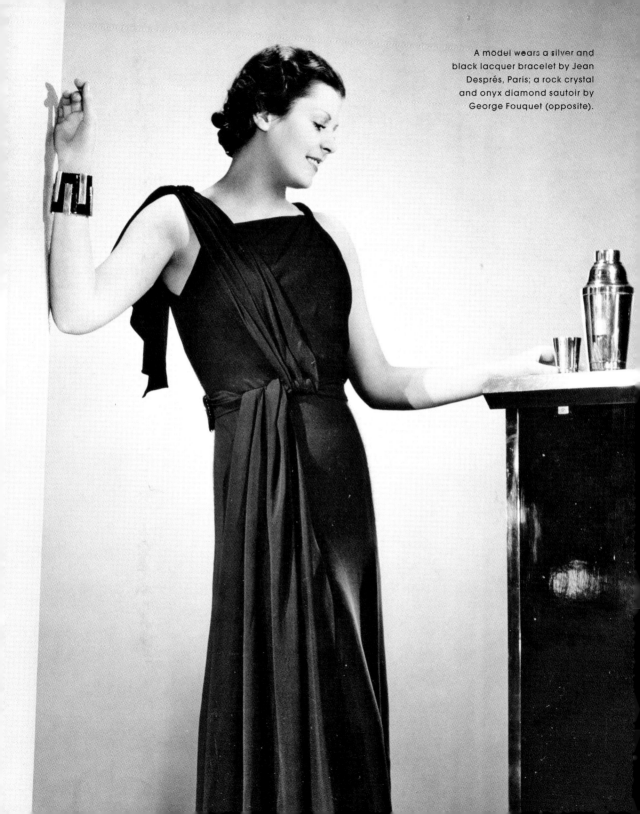

A model wears a silver and black lacquer bracelet by Jean Després, Paris; a rock crystal and onyx diamond sautoir by George Fouquet (opposite).

1926

At a time when others like her—call them heiresses, maybe even It Girls—were draped in art deco diamonds, Nancy Cunard, rebel shipping fortune heiress, lined her arms in wood and gold and ivory bangles from Africa. She wore a gold tuxedo and her father's top hat to a society ball. She supported the surrealists and the modernists, and Ezra Pound and T.S. Eliot. She spoke out against racism and fascism and collaborated with Langston Hughes, and Zora Neale Hurston and W.E.B. Du Bois. She was a fierce defender of the Scottsboro Boys. But you might not be able to tell that from the famous portrait Man Ray made of her, eyes rimmed with inky coal and arms covered to the elbows in exquisite bangles. Or could you?

Bangles in Excelsis

Christie's and the Russians

Christie's holds a sale in London of Russian royal jewels post-revolution but is clear to point out their origins to a Romanov provenance-hungry public: The words "Mostly dating from the 18th century" are highlighted. And a story in a London newspaper further explains "A sale of great historic interest is announced to take place at Christie's on Wednesday, March 16, when some magnificent jewelry that formed part of the Russian State jewels will be put up to auction. They do not include, however, any of the personal treasures of the late Imperial family." Included in the 124 lots is the nuptial crown made around 1844. Many of the diamonds are thought to have come from Catherine the Great's collection. The crown is acquired by Marjorie Merriweather Post who, as wife of the American ambassador to Russia in the 1930s, amasses a significant collection of Russian Imperial art and objects, now on display in Washington, DC, at the Hillwood Museum. Over the course of her life, Post buys and preserves several other historic royal pieces, including Marie Louise's Napoleon diamond necklace and a pair of diamond earrings that belonged to the Empress Joséphine. Had Post not intervened to preserve these historic pieces, many would have been sold for parts. It's why we call her one of jewelry's patron saints.

1927

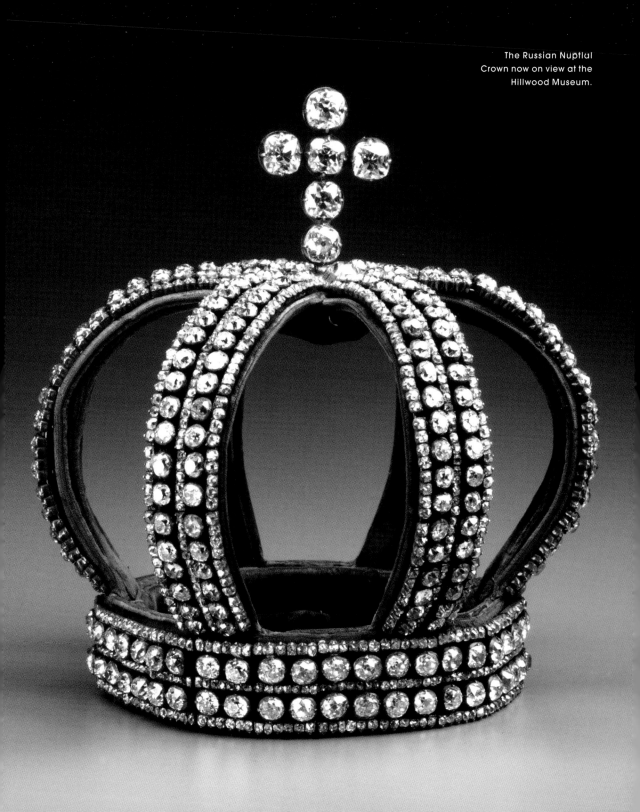

Lost & Found

The Cartier necklace created for the Maharaja of Patiala.

It's a mystery wrapped in a conundrum, 2,930 diamonds, and two very large Burmese rubies. The true twists of fate of the necklace known as the Patiala, after the legendarily extravagant maharaja who commissioned it from Cartier remain unknown, but the five-strand masterpiece still has much to tell. That the maharaja sent the 235-carat De Beers diamond (along with a parcel of other precious gems) to the French house to create "a ceremonial necklace worthy enough for a King" reveals the fruitful relationships that flourished between Indian royals and the great jewelers of the time. Van Cleef, Cartier, Mauboussin, Boucheron, all have rich tales of visits to India, and the jewelry created by these French houses remain some of the most extravagant designs of the twentieth century. (India was not impacted by the economic depression of the 1920s and 1930s.) Not all pieces, however, remain, and that too is part of the story of the Patiala. Its whereabouts until the Maharaja's death in 1938 are clearly document-

ed—he was a man who wore his jewelry proudly and often—and it remained in the family treasury until 1948, when it disappeared under mysterious circumstances. Rumors of financial trouble and the selling of the stones to pay off debt have circulated for years but nothing is known for sure. In 1982, the famed De Beers diamond from the necklace's center turns up at auction at Sotheby's. Where it came from, and where the rest of the necklace was remained a mystery, until six years later when a Cartier representative spied the Patiala, missing most of its precious stones, in an antiques store in London. Cartier bought it and has restored it, though without the original stones. The Patiala necklace is now part of their historical collection, allowing the story to be told each time someone gazes upon its lost splendor.

They
Had Jewels
Then
(Part One)

1930

Gloria Swanson, the highest-paid actress in Hollywood, walks into Cartier and sees six newly designed art deco rock crystal and diamond bracelets. She does not borrow them. She buys two. Herself. She wears them on screen. Watch her go meet Cecil B. DeMille on set as Norma Desmond in *Sunset Boulevard*. The jewels! They are her own.

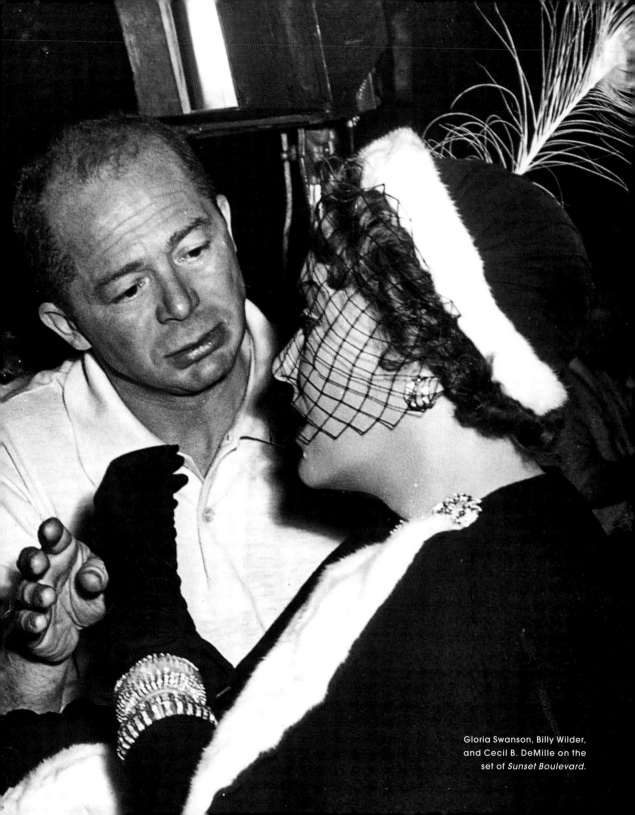

Gloria Swanson, Billy Wilder, and Cecil B. DeMille on the set of *Sunset Boulevard*.

Tell Me Who Your Friends Are

This is a story of jewelry, friendship, and freedom. It was Cole Porter who introduced Sicilian Duke Fulco di Verdura to French designer Gabrielle "Coco" Chanel. He thought Fulco had the kind of cultivated eye that would thrive in the creative hive that was Paris between the wars, and would get on with the fashion designer on the rise. Soon, Fulco is working on jewelry designs for Chanel, and together, their maverick spirit defies conventions of art deco—diamonds, platinum, geometry—and instead yields a cuff of semi-precious stones set in a haphazard-looking, puzzle-like setting in yellow gold. Famed editor Diana Vreeland wears two in her turban. Fulco moves to the USA, setting up his shop in New York in 1939. And that Verdura Maltese Cross Cuff—proof of the power of bucking trends—becomes an icon of twentieth century jewelry design.

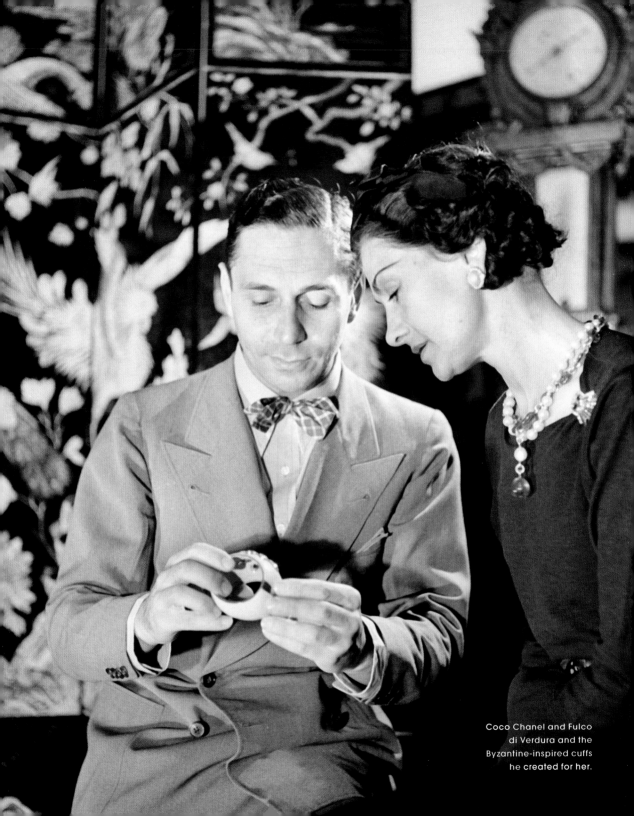

Coco Chanel and Fulco di Verdura and the Byzantine-inspired cuffs he created for her.

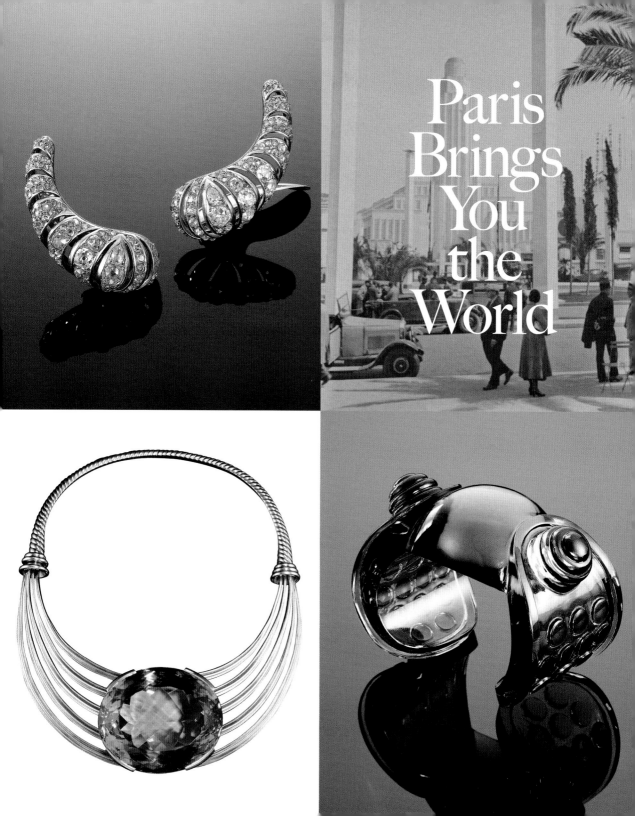

Paris
Brings
You
the
World

The Colonialism Show in Paris inspired
jewelers like Suzanne Belperron to
create pieces with clear tribal and
foreign influence.

The 1925 Paris show that gave art deco its name gets more attention, but the Exposition Coloniale Internationale that took over the Bois de Vincennes in Paris had at least

1931

as much, if not more, influence on jewelry design. Some, like Cartier, Van Cleef & Arpels, and Boucheron exhibited works there; others, like the revered Suzanne Belperron, (whose pieces were so bold and singular she never signed them) visited the pavilions (including a full-scale reproduction of Angkor Wat) where French colonies sold traditional art. The show has been justly dismissed as a national "propaganda effort to justify colonial enterprise" but in many ways its publicized effort to promote an exchange of cultures was successful. The jewels exhibited and inspired by the Colonialism show reflect a global perspective: Boucheron's malachite and ivory armlet, Van Cleef's Chapeau Chinois necklace, and coral and gold collar, brooches set with enamel trading beads, and several examples of pieces finished with tiger's teeth and animal claws set in diamonds. For Belperron, the shapes and techniques on view in the African pavilions proved an especially strong influence. Her work in the period following the show is full of African art motifs such as emerald and hammered gold beads, armbands and chest plates, and her carved quartz pieces took on shapes that reflected the architecture of the domed colonial temples and huts recreated for the Expo. The geometric lines and platinum and onyx palette of art deco still dominated the era but the jewels created for and around this 1931 show remain some of the period's most original.

The all-diamond collection Coco Chanel exhibited in her private apartment in 1932 may have seemed straight out of a fantasy, but it was driven by the harsher reality outside her Coromandel-screened walls. "I started creating costume jewelry," declared the designer, "because I felt that it was refreshingly free of arrogance … this consideration faded into the background during the economic recession, when, there emerged and instinctive desire for authenticity. If I have chosen diamonds, it is because they represent the greatest value in the smallest volume." The logic of showing a diamond fringe tiara and diamond star necklaces and bows and comets was one strategy. Coco Chanel knew this show of support would be a boon to a struggling industry during a European economic depression. It was the only fine jewelry collection Coco Chanel oversaw herself. But the 1932 show inspired the launch of Chanel Fine Jewelry in 1993. And as she was in so many ways, Coco Chanel was a jewelry maverick as well. Her 1932 diamond collection is one of the earliest examples of a fashion designer venturing into the world of precious gems with a signature fine jewelry collection. Now there is almost no fashion house without one.

Chanel to the Rescue

EXPOSITION
DE
BIJOUX DE DIAMANTS
créés par
CHANEL
du 7 au 19 Novembre 1932

chez Mademoiselle CHANEL
29, Faubourg Saint-Honoré, 29

AU BÉNÉFICE DES ŒUVRES
" SOCIÉTÉ DE LA CHARITÉ MATERNELLE DE PARIS "
et
" L'ASSISTANCE PRIVÉE A LA CLASSE MOYENNE "
reconnues d'Utilité Publique

ENTRÉE : **20** FRS

1932

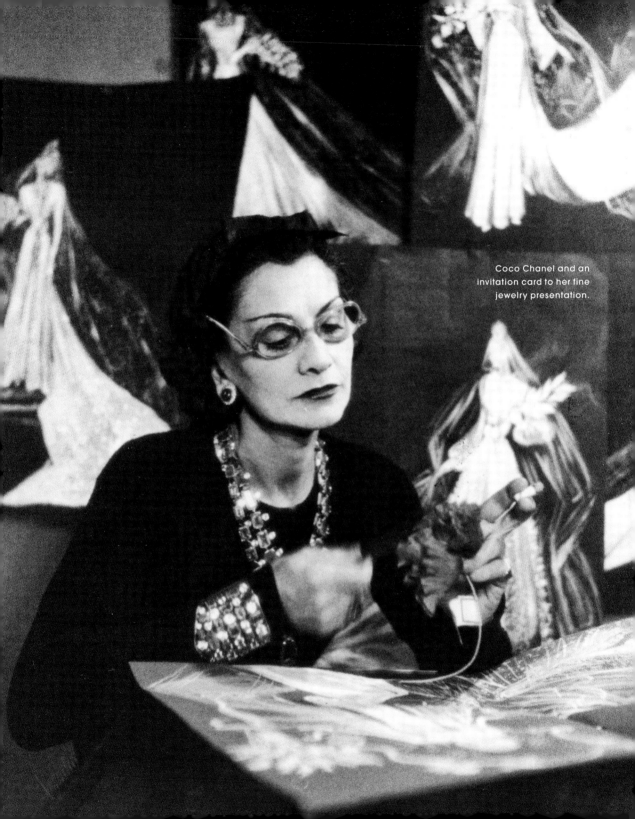

Coco Chanel and an invitation card to her fine jewelry presentation.

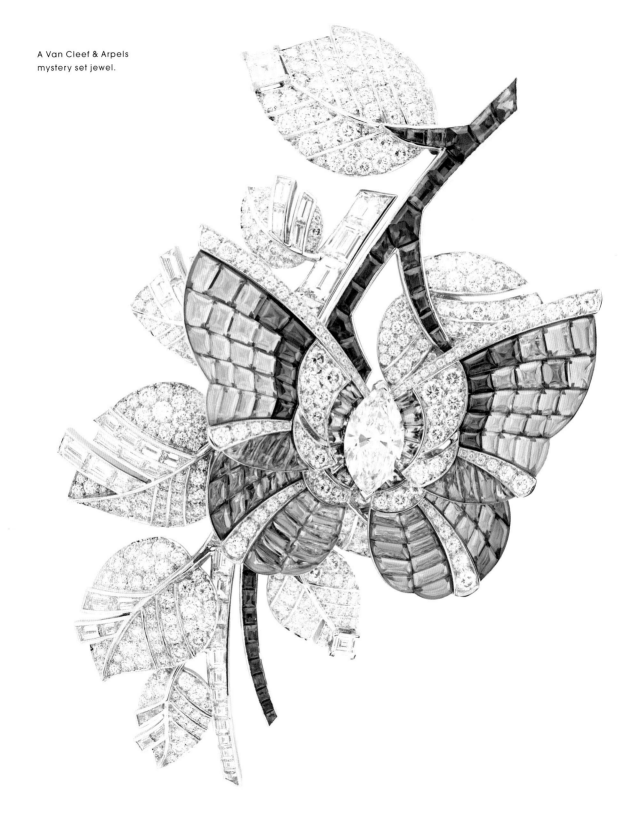

A Van Cleef & Arpels
mystery set jewel.

How'd They Do That?

Jewelry proudly claims its title as the oldest art form, without ever shying away from innovation in technique. In 1933 Van Cleef & Arpels received a patent for the Mystery Setting Technique that would become one of the house's signatures and one of the holy grails of twentieth-century jewelry collecting. The name itself comes from the result of the setting: stones are placed so that no prongs are visible, creating the appearance of almost a blanket of rubies or sapphires. The initial patent reflected work done mainly on flat surfaces but was updated just a few years later when the first three-dimensional Mystery set pieces—like the famed Pivoine ruby and diamond brooch— were created. Mystery set jewels continue to be made (and collected), but given the painstaking process required, only a few are made each year. The phrase "mystery set jewel" in an auction catalogue remains a calling card.

1933

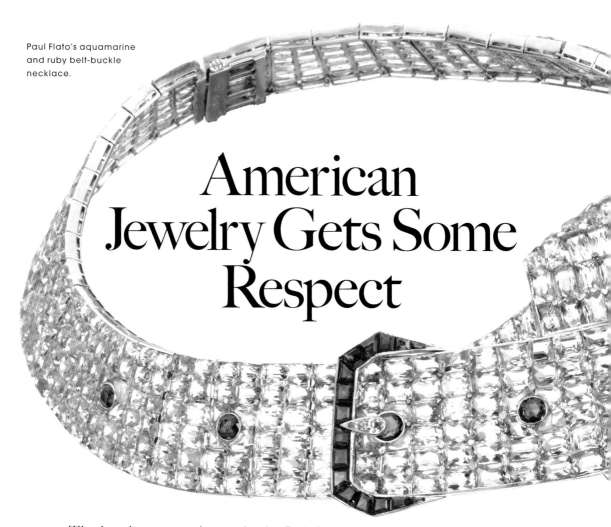

Paul Flato's aquamarine and ruby belt-buckle necklace.

American Jewelry Gets Some Respect

The iconic aquamarine and ruby Belt Buckle necklace designed in 1935 by Fulco di Verdura for Paul Flato was a wake-up call to the world. Paul Flato, the original "jeweler to the stars" was born in Shiner, Texas and opened his business on 57th Street and Fifth Avenue in 1928, quickly becoming a part of New York City's social scene. "He was a schmoozer with good taste," says Ward Landrigan, President of Verdura. "He could steal something from someone and they would smile back at him." And so he did. Two prison terms at Sing Sing and one in a Mexican prison are also part of the Flato legend.

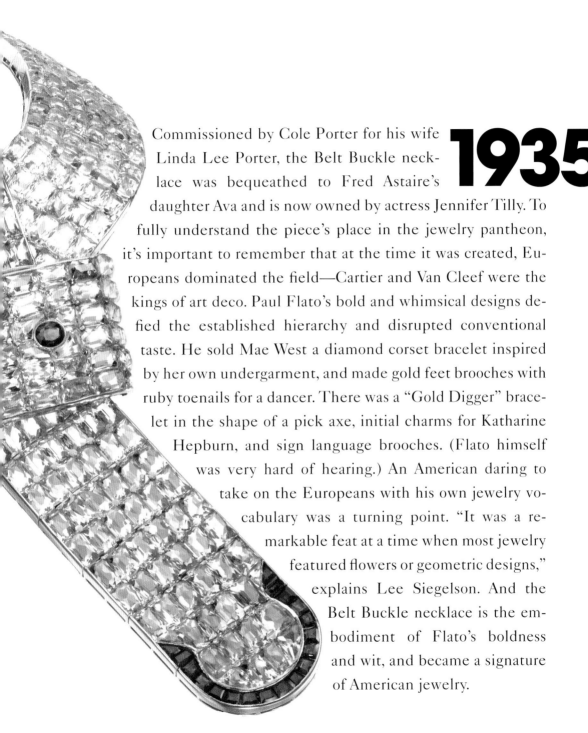

Commissioned by Cole Porter for his wife Linda Lee Porter, the Belt Buckle necklace was bequeathed to Fred Astaire's daughter Ava and is now owned by actress Jennifer Tilly. To fully understand the piece's place in the jewelry pantheon, it's important to remember that at the time it was created, Europeans dominated the field—Cartier and Van Cleef were the kings of art deco. Paul Flato's bold and whimsical designs defied the established hierarchy and disrupted conventional taste. He sold Mae West a diamond corset bracelet inspired by her own undergarment, and made gold feet brooches with ruby toenails for a dancer. There was a "Gold Digger" bracelet in the shape of a pick axe, initial charms for Katharine Hepburn, and sign language brooches. (Flato himself was very hard of hearing.) An American daring to take on the Europeans with his own jewelry vocabulary was a turning point. "It was a remarkable feat at a time when most jewelry featured flowers or geometric designs," explains Lee Siegelson. And the Belt Buckle necklace is the embodiment of Flato's boldness and wit, and became a signature of American jewelry.

1935

Are You There World? It's Me, Wallis

Jewelry was also altered forever the day Edward VIII gave up the English throne to marry the woman he loved. If the couple's politics were dubious, their taste—daring and iconoclastic—was not. The gifts that marked their courtship and their marriage form a timeline of some of the highlights of twentieth-century jewelry history. Would we still be wanting and wearing Cartier Panthers had the Duke not walked into the store asking for one? Would we wear mismatched earrings if Wallis did not favor a black pearl on one side and a white on the other? Would there even be a Van Cleef & Arpels Zip necklace had the Duchess not suggested it? Would there have been a Belperron revival had current owner Ward Landrigan not spotted several unsigned pieces at the sale of the Duchess's jewels in 1987? The Duke is said to have wanted all his jewelry gifts dismantled after the Duchess's death, so no other woman could ever wear them. Luckily for Elizabeth Taylor, who bought the famed Cartier Flamingo brooch at that sale, and Kelly and Calvin Klein who bought those famed pearls—his wishes were not granted.

1937

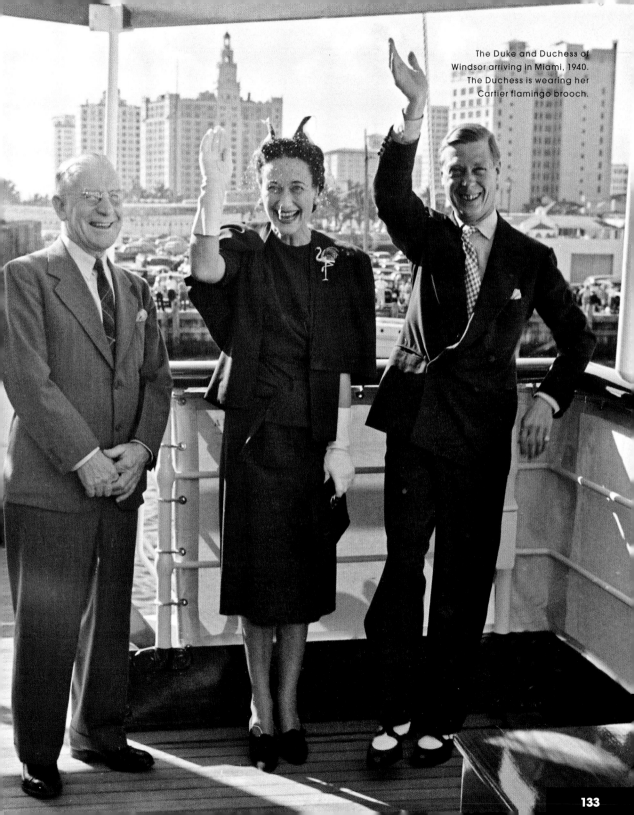

The Duke and Duchess of Windsor arriving in Miami, 1940. The Duchess is wearing her Cartier flamingo brooch.

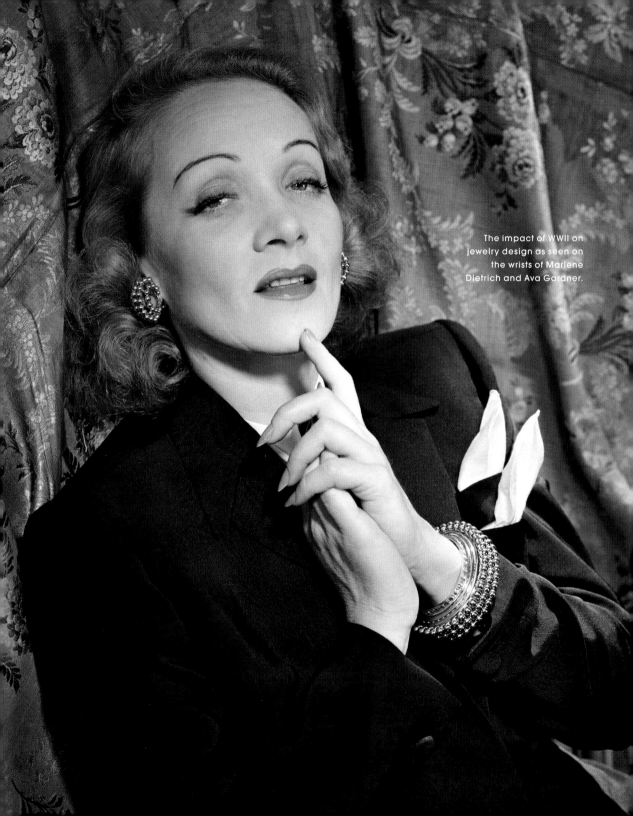

The impact of WWII on jewelry design as seen on the wrists of Marlene Dietrich and Ava Gardner.

The War Effort

Jewelry from the 1940s is easy to spot. First, look for yellow gold. The platinum that defined the jewelry of the preceding art deco age was banned for non-military use during the war, which gave rise the bold yellow and rose gold designs of the 1940s. Then, inspect the stones. The piece likely has a citrine, amethyst or maybe a sapphire, gems designers still had access to outside of blockades and restricted trade routes. Then train your eye on the design. Are there heavy links or tire track motifs that might recall a tank, an engine, or a form of artillery? Yes, images of the weapons of war impacted everyone. We call this style retro now, these bold and high wattage pieces that are often associated with the great cinematic stars of this era, but they were borne largely out of the reality of scarce resources, and the understanding of unabashed glamour's ability to offer—albeit temporary—escape.

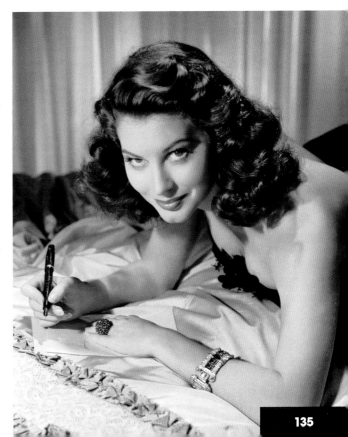

The Best Jewelry Gift in History

The Festoon necklace, designed by Cartier, now part of the collection of Queen Elizabeth.

There are five strands of diamonds. The Cartier Festoon necklace can also be worn more simply with three, but the Duchess of Cornwall seems to prefer maximum impact when she wears the necklace on loan to her from her mother-in-law the Queen. It is one of the many jewels that comprise what might be described as the best jewelry gift in the history of the world: the Greville Bequest. In 1942 society hostess Margaret Greville left almost her entire collection to her friend the Queen Mother. It is unclear just how many pieces were actually in the bequest, though the estimate is about sixty, and we know they include the Greville Boucheron tiara Princess Eugenie wore to her wedding in 2018, a ruby and diamond bandeau necklace the Queen favors, some gorgeous chandelier earrings, and the Festoon necklace. Upon receiving word of her friend's generosity, the Queen Mother put her feelings down on paper: "I must tell you that Mrs. Greville has left me her jewels, tho' I am keeping that quiet as well for the moment! She left them to me 'with her loving thoughts', dear old thing, and I feel very touched. Apart from everything else, it is rather exciting to be left something, and I do admire beautiful stones with all my heart. I can't help thinking that most women do!"

1942

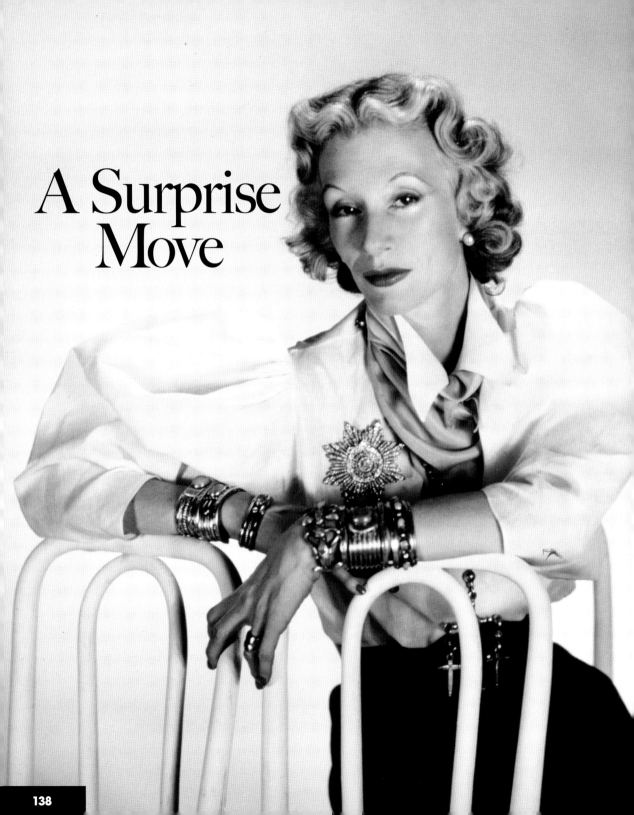

A Surprise
Move

1947

She knew her way around the best parties in Europe and New York (where she is said to have occasionally nursed a 24-karat gold toothpick) and around Schlumberger, René Boivin, Paul Flato, and Verdura, but in 1947 Standard Oil heiress and jewelry collector Millicent Rogers packed up her Charles James wardrobe and moved to New Mexico. The Southwestern bohemian look that decision inspired remains one of the great influencers in how jewelry is worn. Rogers's bold pairing of Native American silver and turquoise jewelry with her famed oversized brooches from the century's greatest designers was a then daring mix of styles. Her legacy can be seen in the museum dedicated to her in Taos and in every modern haute bohemian's white ruffled shirt paired with turquoise earrings and a few well-placed antique diamond rivières.

The ad campaign
that launched a million
proposals.

This landmark De Beers advertising campaign, once voted the slogan of the century, is certainly not the only reason most women want a diamond engagement ring,

1948

but it is likely the leading one. To be fair, the tradition was already in place when female copywriter Frances Gerety of the N.W. Ayer advertising agency proposed "A Diamond is Forever," but it had been weakened by the economic realities of the Great Depression and the perception that diamonds were out of reach for a non-royal, non-millionaire couple in love. De Beers approached Ayer with the assignment to create a campaign that would make every couple planning to get married feel "compelled" to buy a diamond. The agency shrewdly used fantasy to their advantage: they featured celebrities and socialites in the campaign, and made sure that the sizes and brilliance of their diamonds was reported widely in newspaper columns and press releases. In a strategy paper, the agency's plan is clear: "We spread the word of diamonds worn by stars of screen and stage, by wives and daughters of political leaders, by any woman who can make the grocer's wife and the mechanic's sweetheart

A Diamond is Forever

say 'I wish I had what she has.'" Diamonds were, according to their plan, everywhere, but that one line, to quote it, was forever. It is still used in De Beers ads, and has been since 1948, and seventy-five percent of women still get a diamond when they get engaged.

October, 1954, jewelers throughout the
country were asked for the prices of their
o-grade engagement diamonds (un-
ounted) in the weights indicated. The
sult is a range of prices, varying accord-
g to the qualities offered. Exceptionally
e stones are higher priced. Add Federal
x. Exact weights shown are infrequent.

Lover's Dream...painted for the De Beers Collection by Pierre Ino, of Paris

the mysteries of love Love has a language all its own,
sweet and full of secret meanings for each lover's heart. It speaks in
the mountains and the sun, in buds, and in the wondrous lights of an
engagement diamond. And while its voice may some day fade from the mountains,
sun and buds, it lingers clarion clear in the diamond's joyful flames,
repeating the dreams of lovers down their married lifetime and beyond.

Your engagement diamond need not be costly or
of many carats, but it should be chosen with care.
Remember, color, cutting, and clarity, as well as
carat weight, contribute to its beauty and value.
A trusted jeweler is your best adviser. Extended
payments can usually be arranged.

De Beers Consolidated Mines, Ltd.

a diamond is forever

1948

"Emeralds, onyx, diamonds, a brooch!" is what Jeanne Toussaint is said to have exclaimed after spotting a panther while on safari with Louis Cartier. Toussaint, who joined Cartier around 1913, earned the nickname of "La Panthère" from Louis Cartier, perhaps because she wore a full-length panther coat, perhaps because she was ferociously opinionated, perhaps, some say, for other reasons. Toussaint was director of Cartier Jewelry, and soon the Big Cats started prowling the house vitrines. The Panthère can first be spotted in a diamond-and-ebony wristwatch from 1914; that year, a Cartier greeting card featured the feline at the feet of an elegantly dressed woman. But Toussaint had bigger plans than a postcard for the animals, and pushed her team for more three-dimensional pieces. Visits to the Paris zoo ensued. In 1927 Peter Lemarchand joined her team, ready to pounce with the technical skill to realize her visions. Twenty years later, the Duke of Windsor walked in the door. The first three-dimensional Cartier Panthère was created in 1948 for his wife, the Duchess of Windsor, using a 116.74 carat emerald from the Duke's own collection. New year, new Panther. In 1949 the couple commissioned another Cartier brooch, this time pairing a diamond cat with a sapphire; the Duchess is said to have had a preference for blue, believing it brought out her eyes. The sapphire clip brooch was sold at Sotheby's landmark sale of the Duchess of Windsor's personal collection in 1987. Price realized? $1,026,667.

A Panther Pounces

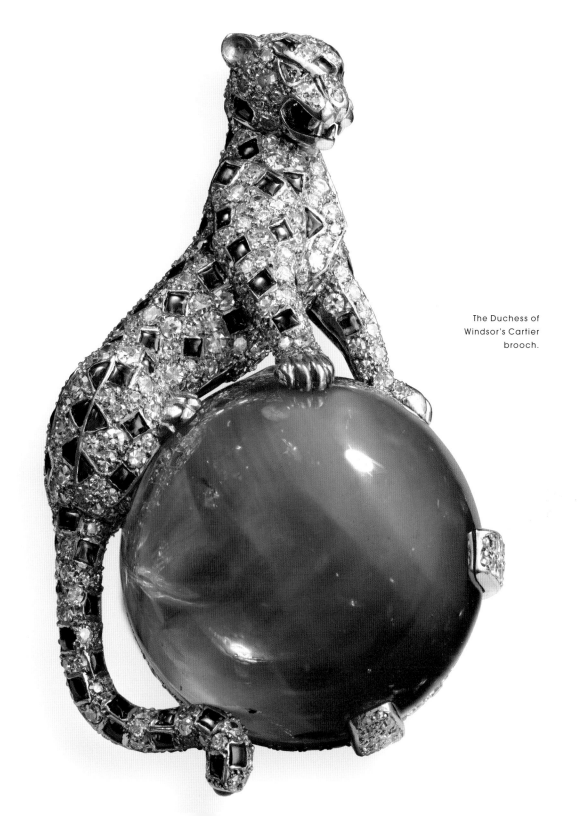

The Duchess of
Windsor's Cartier
brooch.

Road Trip!

Before there were Instagram accounts or viral jewelry blogs, Harry Winston set out to get a wider audience excited and educated about the stones he loved. His Court of Jewels traveling exhibition brought some of history's greatest treasures to American cities and asked the public to pay an admission fee for the experience. Winston donated all the proceeds to local charities but the fee equated the jewels on view with any other kind of art the public might pay to gaze upon in a museum. Winston believed deeply in the value of bringing stones like the Hope Diamond, or Catherine the Great's emeralds, or the Idol's Eye diamond, or a 337-carat sapphire out of vitrines and vaults and into the public, where their historical significance could be taught and appreciated. His mission did not end with the conclusion of the Court of Jewels tour. Winston was intent on creating a national gem collection and donated the Hope Diamond to the Smithsonian in 1958 and the Portuguese Diamond in 1963, where they are visited by millions each year.

1949

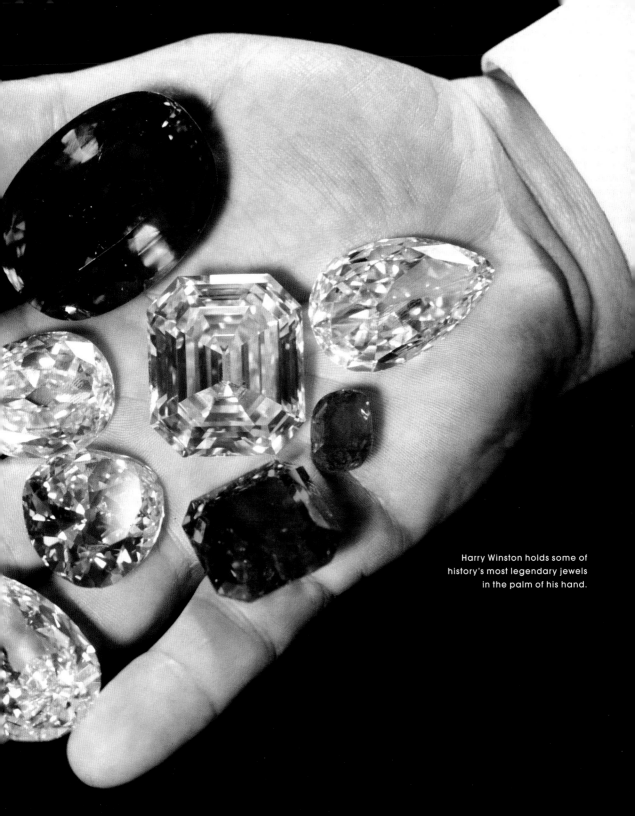

Harry Winston holds some of
history's most legendary jewels
in the palm of his hand.

1950

What is it about jewelry and snakes? Even before the serpent seethed with the symbol of temptation, it slithered its way on to armlets and diadems. The Aztecs and the ancients heralded it as a symbol of fertility and immortality. Cleopatra's arrival in Rome in 46 B.C. sparked an early spiral gold snake bracelet trend. The medieval period didn't much care for serpent jewels, but the nineteenth century's Egyptian revival brought the serpent back to life. And the art nouveau movement never met a snake it didn't want to enamel. The modern jeweler most associated with the snake is Bulgari, ever since it replicated scales and skin using its signature gold Tubogas on jeweled watches in the 1940s. And in a rather glorious example of jewelry past meeting jewelry present, a serpent made its way onto the set of *Cleopatra* via Bulgari fan Elizabeth Taylor, who liked hers made of gold and emeralds and diamonds. The Italian firm continues to create singular Serpentis. So for anyone who has ever read and heeded Diana Vreeland's 1968 memo (she had a custom Serpenti belt she often wore as a necklace) to her editorial staff that warned: "Don't forget the serpent . . .the serpent should be on every finger and all wrists and all everywhere"—the snakes are still there, patiently waiting.

The Eternal Seduction

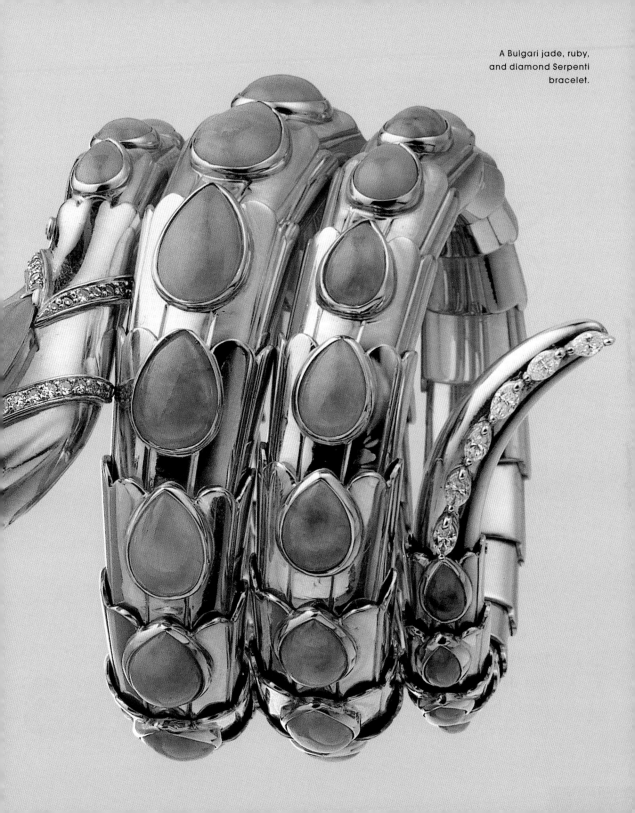

A Bulgari jade, ruby,
and diamond Serpenti
bracelet.

The Screen Queen

The coronation of a king or queen of England is itself a profound testament to the power of jewelry. Almost every ritual in the anointment of a sovereign is marked with it: The Coronation Ring placed on the fourth finger by the Archbishop of Canterbury, the Orb and the Sceptre with the Cross. The Orb—a gold sphere with diamonds and pearls and a golden Cross consecrates the role of Defender of the Faith. The Sceptre, symbolizing that the monarch has temporal authority under God, is set with the second largest diamond in the world. And finally, the Imperial State Crown, whose stones contain multitudes, is placed on the monarch's head. Jewelry, for lack of a better term, seals the deal. Imagine then, actually witnessing this ritual: Queen Elizabeth II's coronation was the first to be televised. Millions around the world experienced the radiance of the George IV State Diadem she wore as she entered. They gazed on the coronation necklace and earrings from Queen Victoria. They watched as gold cuffs were placed on each arm. And could see, thanks to their television screens the full splendor of the Imperial State Crown: the brilliant red spinel known as the Black Prince's Ruby at the center, the Stuart Sapphire in back, the Cullinan II diamond, and in front, the small pearls that might have been the Virgin Queen's. The millions watching that day were exposed to the treasures of one court, surely, but also to the treasures of history and myth that jewelry can hold for us all.

1953

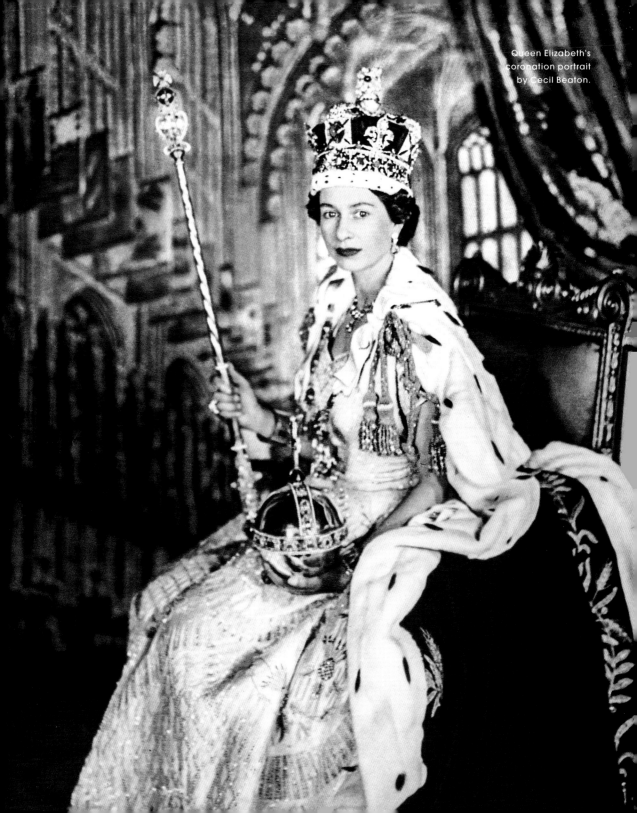

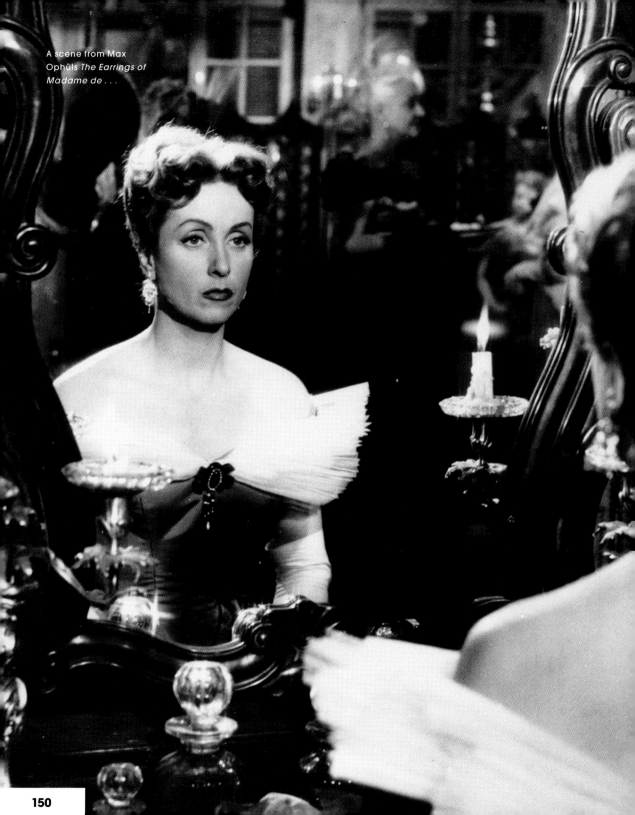

A scene from Max Ophüls *The Earrings of Madame de . . .*

Did Earrings Make Them Do It?

Jewelry as plot point: can an entire film turn on a solitary pair of heart-shaped diamond chandeliers? Yes. In Max Ophul's film *The Earrings of Madame de . . .* , an aristocrat sells the earrings her husband has given her back to the jeweler. (She tells her husband they have been lost at the opera.) A search begins! The jeweler shrewdly claims to find them and sells them back to the husband, who secretly gives them to his mistress. She then unloads them to an Italian baron. They eventually make their way back to the original

1953

aristocrat, and he and the baron end the film in a duel. One man is dead. The earrings however, remain.

GAUMONT-DISTRIBUTION présente une coproduction FRANCO LONDON FILM · INDUSFILMS · RIZZOLI FILM

CHARLES BOYER
DANIELLE DARRIEUX
VITTORIO DE SICA
dans

MARCEL ACHARD

Madame de...

UN FILM DE **MAX OPHULS** · D'APRÈS LE ROMAN DE **LOUISE DE VILMORIN** · DIALOGUE DE **MARCEL ACHARD**
Adaptation cinématographique de MARCEL ACHARD-MAX OPHULS · avec ANNETTE WADEMANT
avec **JEAN DEBUCOURT**
Musique de OSCAR STRAUS et **MIREILLE PERREY** CHRISTIAN MATRAS
GEORGES VAN PARYS **LIA DI LEO**

A few years in the life of a royal diadem: It began as a wedding gift from Napoleon to Marie Louise in 1810 and was accompanied by a comb, a necklace, and earrings. It was fitted with seventy-nine emeralds. It left France with its owner when her husband's empire collapsed and remained with her family until 1953 when one of them sold it to Van Cleef & Arpels. It was exhibited in the firm's window and garnered much interest. It was soon pictured in a newspaper advertisement seductively offering "an emerald for you from the Napoloenic tiara." It soon becomes a diadem of diamonds and Persian turquoise as provenance-mad clients buy up an Emperor's emeralds. It becomes the subject of fierce debate. Swapping turquoise for emeralds? Selling off historical artifacts? Many defend the action as giving the jewels a new chapter and the public the ability to wear and keep history alive. (And that cycle continues: in 2014 a brooch containing one of the Napoleonic emeralds sold by Van Cleef appeared at auction.) Some simply preferred the turquoise. One in particular: Marjorie Merriweather Post (a recurring jewelry savior) bought the diadem from Van Cleef and donated it to the Smithsonian in 1971, where it remains on view. But first, she wore the turquoise and diamonds herself.

From Napoleon with Love

1954

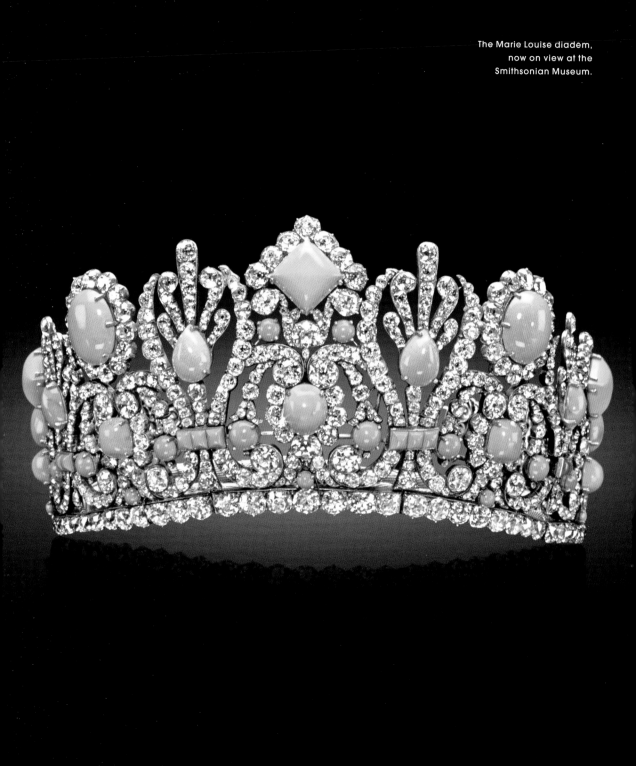

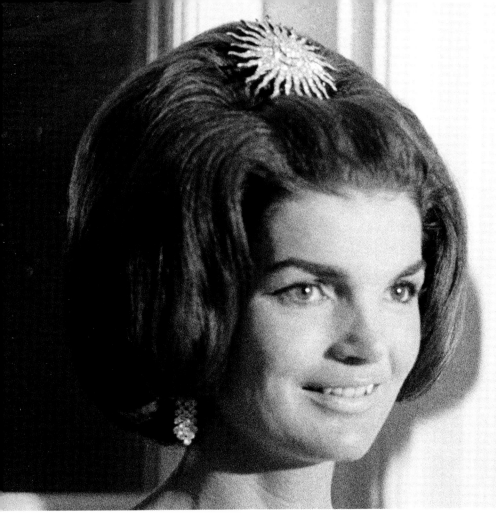

1962

Diamonds & Dinner

The jewelry stakes were high when the Emperor and Empress of Iran visited the Kennedy White House. And for their official State Dinner, Empress Farah wore the Seven Emeralds tiara Harry Winston had created for her. Jacqueline Kennedy had no such royal headgear, but her sense of style, and a bit of cunning from her hairdresser Kenneth with a nineteenth-century sunburst brooch put the First

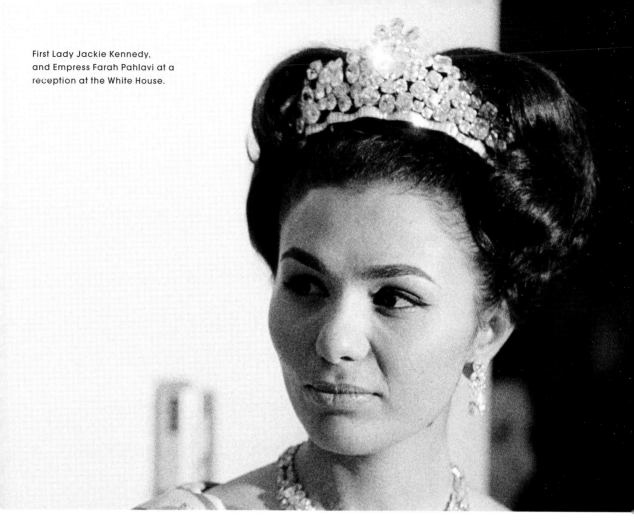

Lady on equal footing. She had spotted it at Wartski in London, but at $50,000, the price was a bit steep. So, she traded some diamond pieces her in-laws had gifted her at her wedding in exchange for the brooch, then had copies of those pieces made. Her in-laws never suspected, and the brooch became one of her signatures. She often wore it in her hair—a kind of American crown?—as she did for the State Dinner. It was also, notably, not among the many jewels sold at Sotheby's 1996 landmark auction of her personal collection: Her daughter Caroline Kennedy Schlossberg continues to wear it proudly.

HEIST!

Sometimes a jewelry twist of fate is the work of history, empires lost and found, a nation's treasures plundered, a queen's abruptly interrupted reign. And **1964** sometimes it's because of a faulty alarm, an open window, and a guy called Murph the Surf. There is a colorful timeline to be written about the great jewelry heists of the world, but we will focus here on the biggest one in New York history and on its (mostly) happy ending. The Star of India is a 563-carat sapphire. Its tale likely goes back almost four centuries, but its life in New York began when J.P. Morgan donated it to the American Museum of Natural History in 1913, part of the historic gem collection curated for the financier by Tiffany & Co. gemologist George F. Kunz. The Star of India had its own vitrine in the museum's Hall of Gems but its trip alarm wasn't working the night Jack Murphy, Allan Kuhn, and Roger Clark slipped in through the fourth-floor window and stuffed the Star of India and diamonds, aquamarines, emeralds, a ruby—about twenty-four pieces in all—into an airline shoulder bag. And this is how the Star of India's life story, which began in Sri Lanka, came to include a trip to Miami. The men were arrested, one in New York, the other two in Florida; the best-known was Jack Murphy, whose previous life as a surfer earned him his press-perfect nickname. The stones remained missing, and given the cardinal rule of jewelry heists—the longer they are missing the more likely they will be dismantled and sold off and therefore untraceable—time was of the essence. About half of the gems stolen in the heist remain at large, but The Star of India was eventually recovered in a locker in a Miami bus terminal. The thieves got about two years each and the Star of India returned to its old home in the Hall of Gems. This time with its own security guard.

The Last Empress

They are located in the National Treasury of Jewels inside the Central Bank of Tehran, but for most of us, they are just pictures. The Imperial Crown Jewels of Iran is a collection, one of the best in the world, that dates back to the sixteenth century but also includes pieces created by modern houses like Harry Winston (Empress Farah's wedding tiara) and Cartier (a necklace made from Empress Eugénie's emeralds) and Van Cleef & Arpels. They were last worn publicly by the Shah of Iran, Mohammad Reza Pahlavi, and his third wife, Empress Farah Pahlavi, whose reign was overthrown during the 1979 Revolution. The royals fled; the jewels of the state stayed behind. It was he, the last Shah, who had insisted that jewels and objects long hidden in vaults be exhibited to the public. And it was he and his wife who had given the Western world a glimpse of this majestic collection that included a golden throne studded with rubies, emeralds, and diamonds. Images of their 1967 coronation reveal its splendor: Empress Farah, in a custom Dior gown, wears a crown of 1,541 stones, including 1,469 diamonds, thirty-six emeralds, thirty-four rubies, two spinels, and 105 pearls, and a 150-carat emerald set at the center. The 4.3-pound crown, as well as her emerald necklace and earrings, was designed by Van Cleef & Arpels. The firm reportedly set up a workshop in the Treasury basement, as the stones were too valuable to leave the country. They still are, and now are used as reserve to back Iran's currency.

1967

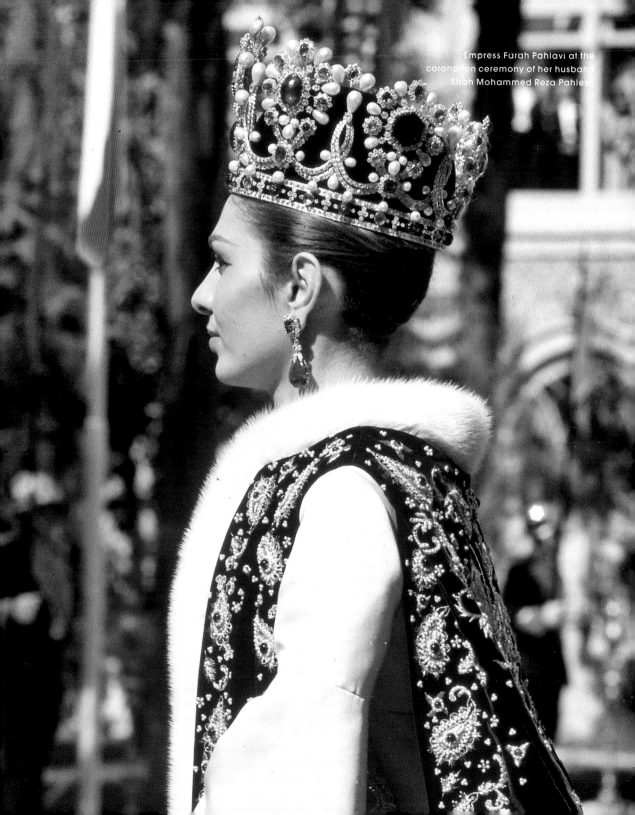

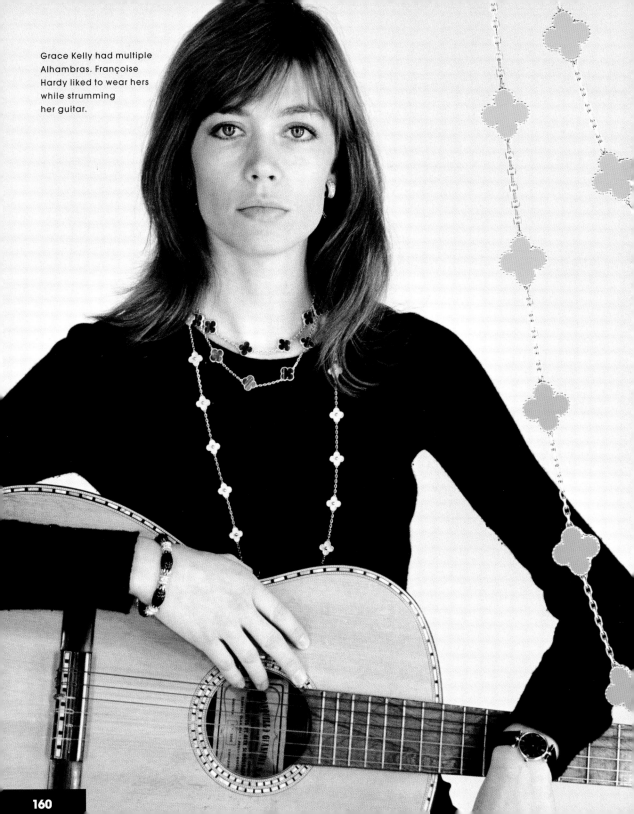

Grace Kelly had multiple
Alhambras. Françoise
Hardy liked to wear hers
while strumming
her guitar.

Van Cleef Gets Lucky

"To be lucky," Jacques Arpels once said, "you have to believe in luck." Clearly, he did, having designed a jewelry icon inspired by a clover. The original drawings for the Van Cleef Alhambra appear in the archives from 1968; flower-and-clover shapes go back much further, but the birth of the Alhambra style—a four-leaf clover strung on a simple gold chain or bracelet—happened at a turning point in the late sixties when loosening cultural codes demanded wearable, less formal jewels to match the spirit of the time. The style continues to stoke the flames of collectors' desire: track prices every time the rare turquoise, tiger's eye, or lapis styles appear. Widely coveted and widely copied, the Alhambra set a standard for the jewelry industry in the creation and marketing of a collection. Many designers refer to their desire to create an icon for their house that is both recognizable and relatively accessible as a "search for their own Alhambra." They do not, however, all get this lucky.

1968

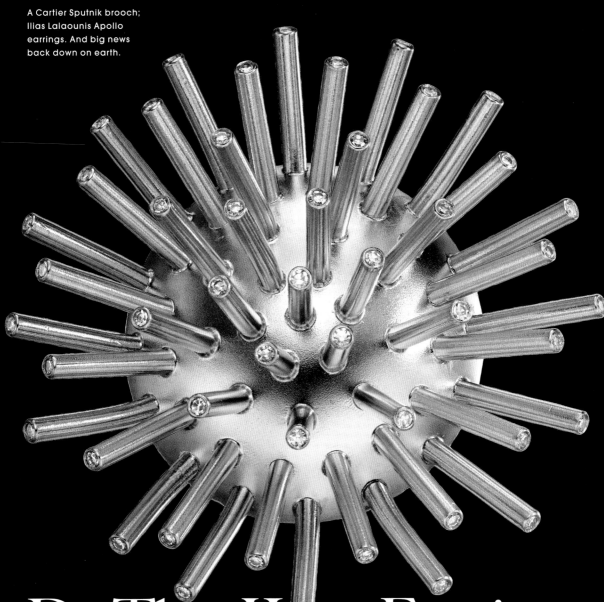

A Cartier Sputnik brooch; Ilias Lalaounis Apollo earrings. And big news back down on earth.

Do They Wear Earrings on the Moon?

1969

The Apollo moonwalk was one giant leap for mankind but also made enormous strides for jewelry. The era of space exploration proved fertile ground for jewelers' imaginations: "One of my favorite designs made after the moon landing," says vintage jewelry dealer Lee Siegelson, "are Jackie O's Crater Cuffs by Van Cleef & Arpels. They are hammered and pitted, creating a lunar like surface." Ilias Lalaounis created orbit-shaped Apollo earrings by commission that summer, a birthday gift from Aristotle Onassis to Jackie. The Sputnik launch was referenced in Cartier's late 1950s gold-spiked brooches of the same name, and the house continued to mark this territory with the creation of Lunar Module replicas to commemorate the 1969 moon landing. But they were not the only ones inspired by what was happening above. "Pol Bury made an interesting variation on the Sputnik design, adding a kinetic element and making the 'rays' slip in and out of earrings and rings," says Siegelson. Literal adaptations of space shapes are indications of how the era inspired jewelers, but the moon landing and images that followed also shifted how jewelers worked with materials. Textures became rougher, and stones were introduced in raw cuts. We saw a new world, and jewelers responded accordingly.

A Royal Shocker

"Something that is modern," is how Prince Charles's Prince of Wales coronet has been described, and it's what was needed. The late 1960s was a delicate time for the monarchy. There were labor protests in England, power outages throughout the country, an oil shortage, uprisings in Wales. The investiture of Princes Charles as Prince of Wales needed a crown to match the mood of the era. Enter Louis Osman, whose vision was to create a coronet that would provide drama and meaning but with modernity. The single arch of the coronet follows the form set down by King Charles II in 1677. The *monde* is inscribed with the Prince of Wales's insignia and a plain cross. Diamonds on the *monde* are in the shape of the sign of Scorpio (Princes Charles's birthday is November 14). At the base are four crosses and four fleur-de-lys. They are decorated, albeit sparsely, with diamonds and emeralds. The diamonds represent the seven deadly sins and the seven gifts of the Holy Spirit. Inside the coronet is a cap of purple velvet lined with ermine. The cap addressed Charles's request for a coronet that could be worn by a modern Prince of Wales, without a wig. Louis Osman's design began by taking a mold of the Prince's head, creating a resin case, and then layering it in gold. As with all experiments, along the way, there were a few mistakes. There was barely any time left before the investiture for Osman to finish, so a technician reportedly came up with the idea of electroplating a ping-pong ball to achieve desired height. It worked. The ping-pong coronet was seen around the world. Charles's Prince of Wales investiture ceremony, masterminded by Lord Snowdon, took place under a transparent canopy and was televised. Charles's coronet may just be the most modern royal jewel of all.

1969

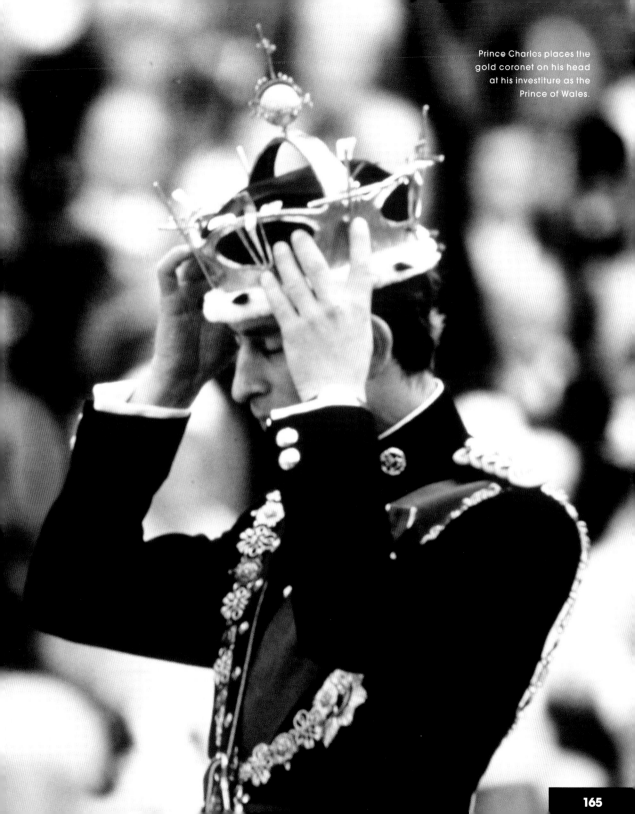

Prince Charles places the gold coronet on his head at his investiture as the Prince of Wales.

1969

The tools of industry have long fueled jewelry design. A recent excavation of a Mycenaean tomb yielded a pendant depicting agricultural practices. Bracelets in the 1940s were inspired by tire and tank tracks. Bulgari's signature Tubogas design has roots in machine piping. But has anyone capitalized on the potential of the manmade as well as Aldo Cipullo? The Italian designer arrived in New York in the late 1960s when the idea of "everyday" jewelry was beginning to take hold. The Van Cleef & Arpels Alhambra had just been introduced and Pomellato was founded in 1967 with the idea of "pret-a-porter" gold in mind. In the midst of an industry questioning jewelry doctrine, Cipullo found his place. He worked at Tiffany & Co. and David Webb, where he introduced the idea of the nail ring, before landing at Cartier. He grasped the shift from sentimentality in the zeitgeist and created a token of love that was devoid of saccharine sweetness. The Love bracelet is a simple gold cuff studded with screws that could be put on and taken off only with a screwdriver—the everlasting bond of love expressed in metal. This was not a piece a man or a woman—Cipullo designed it be unisex, also unusual for the time—could easily remove, which swept away the old idea that jewelry should be kept in a safe and worn only on special occasions. People wore their Love bracelets to work, to dinner, in the shower, and into bed. This idea of jewelry for everyday seems almost like ritual now, but, at the time, it was a quiet revolution.

The Power of Love

Designer Aldo Cipullo, creator of the Love bracelet.

They Had Jewels Then (Part Two)

"I was going to get that diamond if it cost me my life or two million dollars, whichever was greater," Richard Burton said of the sixty-eight-carat rock Elizabeth Taylor wore to the 1970 Academy Awards, to present the Best Picture Oscar to *Midnight Cowboy*.

The Taylor-Burton diamond became that after a twenty-four-hour battle between Burton and Cartier, who outbid him at auction when the firm paid a record price of one million dollars. He seduced it out of their hands and onto Liz's neck for $1.1 million. But first it went on tour so the public could witness its splendor, a condition of the sale. There were lines around the block outside Cartier's New York and Chicago stores. Taylor refashioned the diamond into a necklace; the stone was heavy, and she wanted to something that would hide her tracheotomy scar from an almost fatal bout with pneumonia. Images of Taylor on stage at the Dorothy Chandler Pavilion serve as artifact of an era when actors and actresses wore their own pieces to events and award shows, before the modern practices of borrowing pieces or being contracted to wear a certain designer became commonplace. After her second divorce from Burton, Taylor sold their named diamond for a rumored $3.5 million.

1970

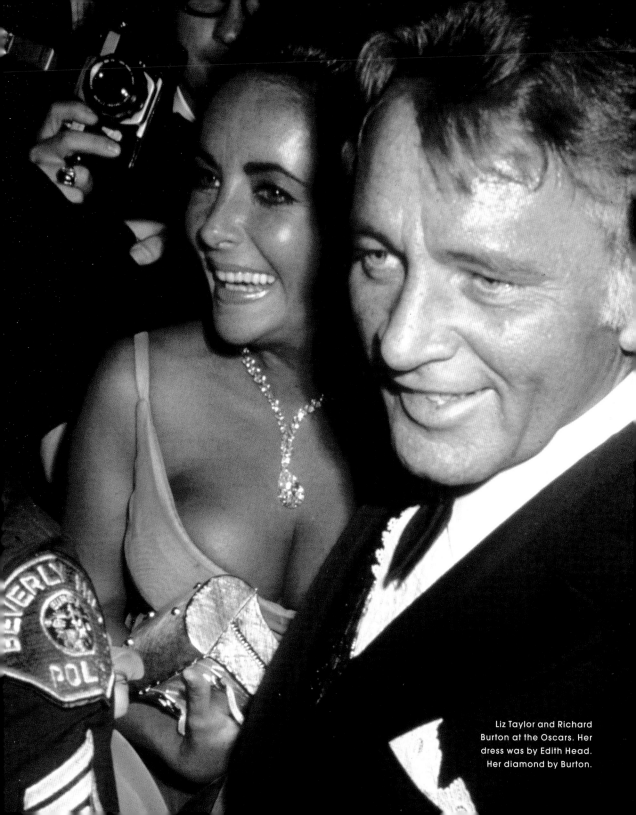

Liz Taylor and Richard Burton at the Oscars. Her dress was by Edith Head. Her diamond by Burton.

Who Was Ganna Walska?

Her name is spoken in reverent tones by jewelry nerds everywhere. An original catalogue of the sale of her jewelry at Parke-Bernet (now Sotheby's) is collected like early editions of the Gutenberg Bible. Ganna Walska was a Polish opera singer who loved rare jewels and rare plants (she established the Lotusland garden at her estate in Montecito, California). She married six times (four times very well). Her jewelry collection was as singularly magnificent and eccentric as the plants at Lotusland, but the catalogue is legend more because of what is not in it as for what is.

Namely, information. Several Suzanne Belperron pieces were not identified as such. That two-hundred-carat sapphire in the sale? It wasn't until the 1990s that it was identified as a stone with Russian royal provenance, one of the still-remaining pieces pictured in the famed Fersman catalogues of the Tsar's collection that did not appear in the 1927 Christie's auction of Russian royal jewels. There was also the ninety-five-carat fancy yellow diamond briolette, eventually categorized as Fancy Vivid in color, one of the largest of its kind ever recorded. Some people, including Doris Duke, who bought the India Arya necklace for $2,600, got really lucky that day.

This was Ganna Walska. And these were her jewels.

105,000

125,000

33,000

16,000

24,000

59,000

37,000

65,000

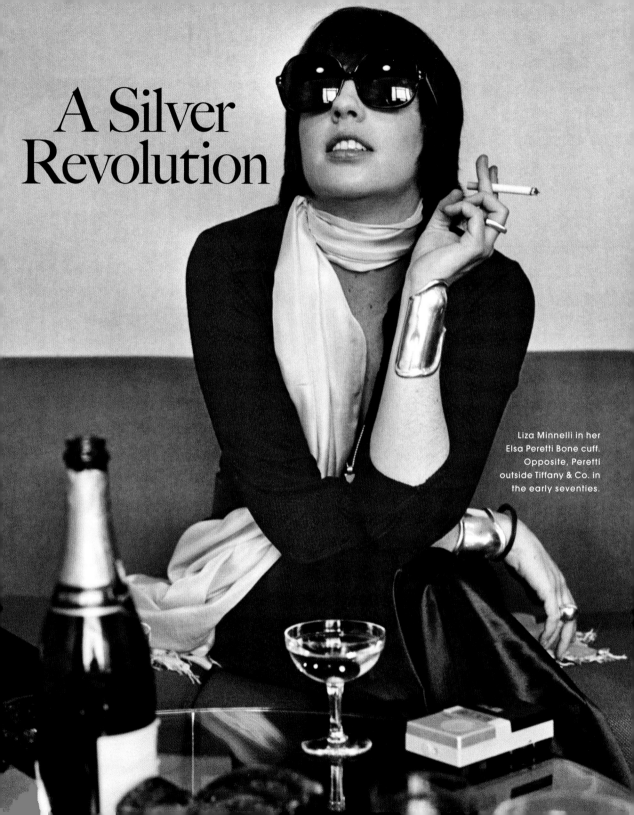

A Silver Revolution

Liza Minnelli in her Elsa Peretti Bone cuff. Opposite, Peretti outside Tiffany & Co. in the early seventies.

Was it an Italian aristocrat who democratized American jewelry? When Tiffany & Co. chairman Walter Hoving signed Peretti to an exclusive contract—via an introduction from her friend Halston—the store had not sold silver jewelry for twenty-five years. But Hoving had issued a call to arms in a pamphlet titled "Can Good Taste Survive in America?" He declared that "the rules of taste have nothing to do with price. A low-priced article can be just as attractive as a high-priced one if it is properly designed." Peretti's pared down, powerful designs proved him right. Her singular talent, as the *New York Times* described her record-breaking return for Tiffany & Co. in 1978, was turning "anonymous symbols of affluence into expressions of pure design." It made her, and Tiffany & Co., millions in the process. And still does. After Peretti began stripping jewelry of its pretension—getting stars like Liza Minnelli and Sophia Loren back into silver, and introducing a whole new audience to diamonds with her then-one-hundred-dollar Diamonds by the Yard designs—*Newsweek* published a cover story stating that her designs started a jewelry revolution akin to the Renaissance. The revolution in open-heart pendants, scorpion necklaces, bean earrings, and bone cuffs, continues: At a recent exhibition of American jewelry at the Metropolitan Museum of Art, her sterling silver bone cuff held pride of place.

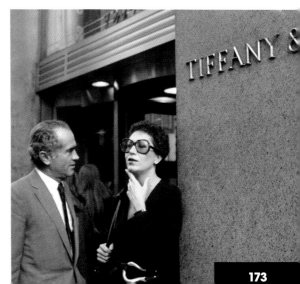

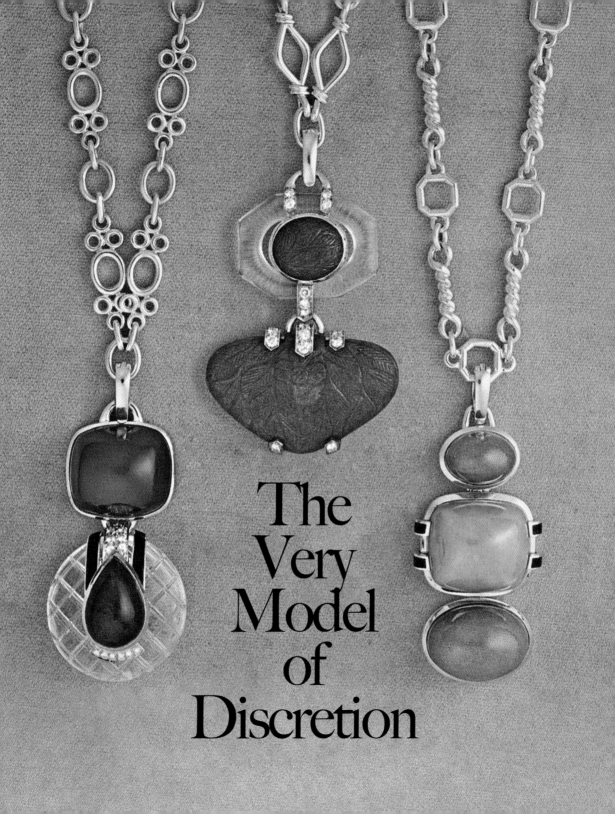

The
Very
Model
of
Discretion

A notorious headline and
the David Webb necklaces
it inspired.

1975

What does a gem-studded necklace owe to the New York financial crisis and Gerald Ford? Jeweler David Webb, born in Asheville, North Carolina, arrived in New York in 1942 with enough backing from friends to open his first shop by 1948. Webb's voluptuous designs worked well in the post-war years with a booming society scene in New York and the bodacious figures of Hollywood. By the 1960s, his brooch was on Liz Taylor's lapel, and Jacqueline Kennedy asked him to create gifts for White House guests. He used jade, coral, and rock crystal liberally, and developed a signature look with hammered gold. "I had always been fascinated by very early jewelry," he once said. In the early 1970s, the past caught up with the present when New York almost went bankrupt and the federal government refused to help. The clients who depended on Webb for enormous diamond cocktail rings felt the need for a bit more subtlety. Webb responded by putting together a necklace of stones few would recognize the value of—malachite, tiger's eye, lapis—and string them together in a design that had enough mystery to keep onlookers guessing: "Was that thing real?" The David Webb Totem necklace was. The now iconic piece was influenced by Webb's knowledge of ancient jewelry, but its origin story is one of modern ingenuity.

Cartier Crocodile Attack

They say she walked into the store with her pet crocodile and asked if he could spend the night. María Félix, the Mexican actress known as La Dona, thought the jewelers at Cartier might need to examine the specimen up close before creating the necklace she commissioned in its honor. One look, they decided, was all that was required to create the piece resembling two fully articulated crocodiles using 1,023 yellow diamonds, 1,060 emeralds, and two cabochon

rubies. The Cartier María Félix piece holds a place in jewelry necklace royalty, which also includes Marie Louise's diamond necklace, the Patiala necklace and Daisy Fellowes's Tutti Frutti. It certainly merits recognition as an artistic achievement and a feat of engineering (and perhaps also as an example of indulging the whimsies of the rich and famous) but it has earned its place also as a symbol of unapologetic excess. The same year the necklace was commissioned,

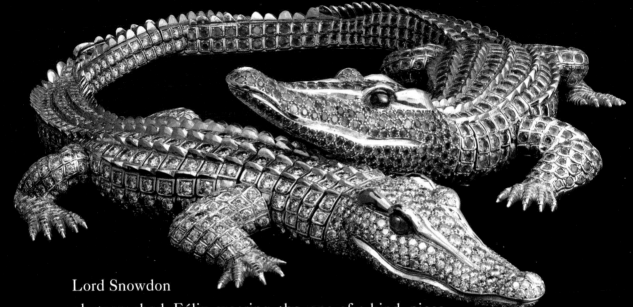

Lord Snowdon
photographed Félix wearing the one-of-a-kind piece,
along with two serpent cuffs and several gold link bracelets, multiple
rings, and a large black hat with a jeweled double belt looped around
like a hat band. A cigarette rests between her lips with a significant
amount of ash just about to drop. "Too much?" she seems to be asking.
"I don't think so." And in 1975 it certainly wasn't. And in a testament to
the eternal power of eccentric personal style and jewelry's role in creat-
ing a signature (reference Edith Sitwell, Peggy Guggenheim, Millicent
Rogers) the image of Félix with the jeweled crocodile around her neck
is one widely Instagrammed jewelry portraits. Only one person other
than Félix has ever worn it—Monica Bellucci paired it with a simple
white shirt and black ball skirt for the 2006 Cannes Film Festival—and
it is now owned by the Cartier Collection. (Félix sold most of her jew-
elry before she died.)

1981

People talk of the secret language of jewelry snobs. Conversations that are often punctuated by emphatic clarifications—"It's nineteenth-century Egyptian revival, not art deco," "It's Cartier, Paris"—and even more often marked by emphatic declarations of origins. The aquamarines must be Santa Maria, the emeralds Colombian, the turquoise Persian, and the Paraibas Brazilian. The search for the Paraiba began as one man's quest for the new. Hector Dimas Barbosa dug deep in the hills of Paraiba, Brazil, driven by a hunch that there was untold treasure there. It was years before he struck upon a stone with a color most accurately described as "Windex blue" (not an official term, but one that is widely used). Soon, Paraiba tourmaline became hunted by jewelers and collectors alike. As with many natural resources, supply could not keep up with demand. The original Brazilian "Windex blue" stones have been almost impossible to find after the mine dried up due to heavy demand since Brazilian Paraibas came on the market in force in the 1990s. Jewelers swear Mozambiquian Paraibas are gaining in quality, but they still present a piece with particular pride when they are able to say, "It's Paraiba, a Brazilian."

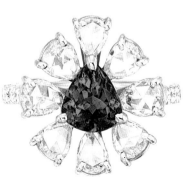

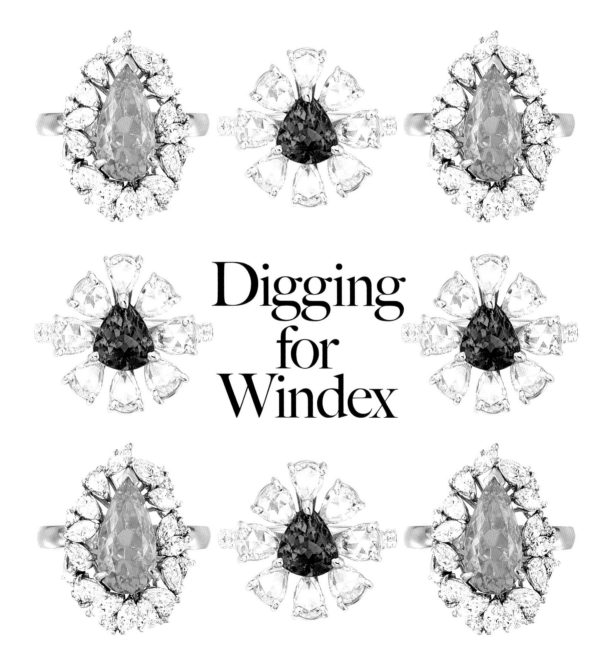

Digging for Windex

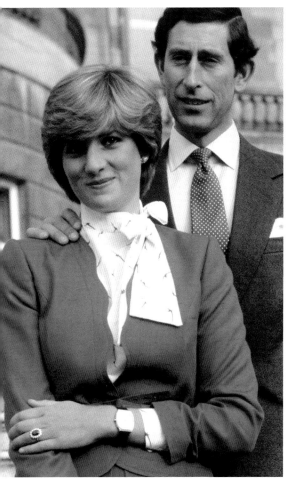

In an unofficial poll of jewelry experts and obsessives, this was the most **1981** significant moment in jewelry history: Charles, Prince of Wales proposed to kindergarten teacher Lady Diana Spencer with a twelve-carat Ceylon sapphire surrounded by fourteen diamond solitaires in the nursery at Windsor Castle. The ring (which now belongs to the Duchess of Cambridge, who received it as her engagement ring from the couple's oldest son, Prince William, in 2010) had no royal provenance and had not been specifically commissioned for the occasion. It was, in fact, available to anyone with access to a Garrard catalogue and approximately $60,000. From the very beginning it seems, Diana was the People's Princess.

It Could Have Been You

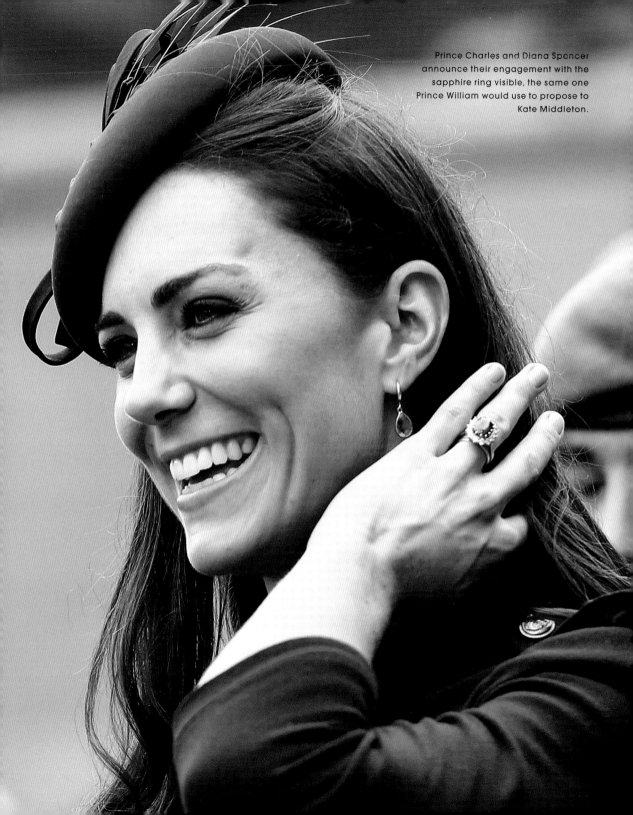

Prince Charles and Diana Spencer
announce their engagement with the
sapphire ring visible, the same one
Prince William would use to propose to
Kate Middleton.

1981

There were heavily padded shoulders, nipped waists, pencil skirts, wide-brimmed hats, fox stoles. And there were jewels: big v-shaped necklaces with earrings that matched. Joan Collins's character on *Dynasty* was certainly a reflection of the time they call "The Greed Decade" replete with caviar and champagne, and diamonds, rubies, and sapphires. It was not subtle jewelry; its message was clear, and its message was money.

Alexis Morell Carrington Colby Dexter Rowan

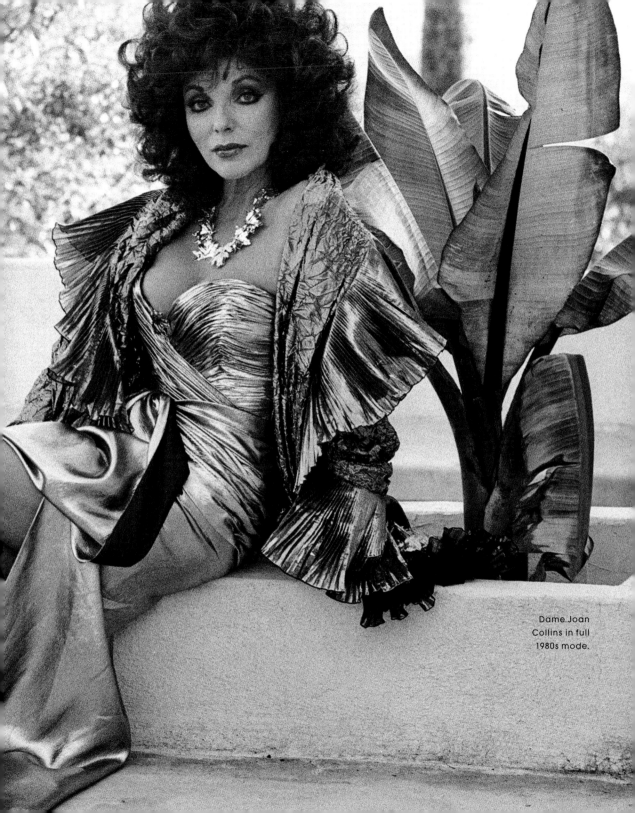

Dame Joan
Collins in full
1980s mode.

1983

Some have compared the design to a helix or DNA mapping. David Yurman was a sculptor before he introduced the world to his Cable bracelet, and the intertwined bands of metal are, whatever their initial inspiration, representative of his innovative fusion of art and industry. The Cable reflects the hand-welding process in his early work and the now-signature piece is, for the millions of people who buy it at his stores around the world, an introduction to jewelry. For that impact alone the Cable deserves a place on this timeline, but its broader contribution is in its daring, innovative marketing of jewelry to a wider public. In many ways, the Cable bracelet brought jewelry into the American living room. It also promoted the idea of the independent American designer: it was

The Art of Commerce

Yurman who asked that his jewelry be displayed clearly under his name in department stores, where jewelry had long been shown grouped together by category.

The David Yurman
cable bracelet rendered
in titanium.

The Royal Rebel

Is this jewelry as rebel yell? There were certainly jewels she wore more often—the Cambridge Lover's Knot Tiara, that sapphire and diamond necklace, the Spencer family pearls—but if there was one jewelry signature that defined Diana's individuality, it was the moment she decided that the art deco emerald and diamond choker that Queen Elizabeth had given her as a wedding gift, the one that dated back to Queen Mary, would look really great as a headband. She wore it, to dance with her husband, Charles, Prince of Wales, during an official tour of Australia.

1985

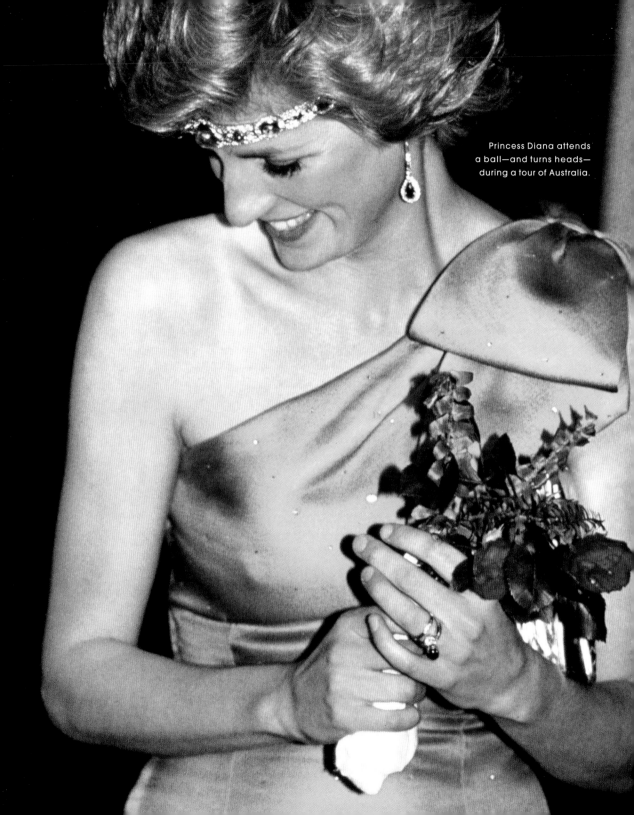

Princess Diana attends a ball—and turns heads—during a tour of Australia.

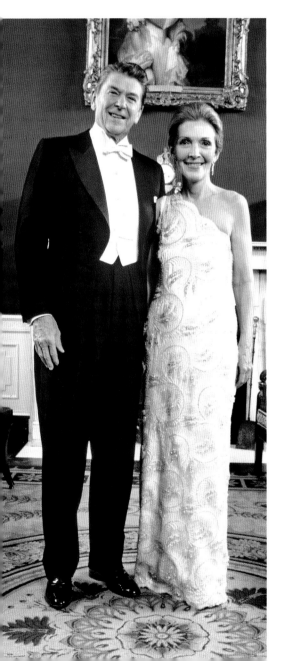

1986

What is the jewelry equivalent of Gordon Gekko's power suit? As fashion reflects the era in which it is created, so too does jewelry. The lean silhouettes of the 1920s flapper can be seen in the strict geometry of art deco diamonds. Queen Victoria's black mourning clothes are reflected in the dominance of Whitby Jet jewelry. The high glamour of Hollywood suiting of the 1950s can be spotted in the equally bold gold cuffs and bib necklaces of the era. And what about the 1980s, that era of big hair and bigger shoulders? How will the jewelry of this age of excess be remembered? Like this American flag ring Bulgari made for President and Nancy Reagan: bold and brash and the opposite of subtle.

It Was the 80s, Ok?

A Bulgari ring formerly
in the private collection
of Nancy Reagan.

Sometimes a jewelry trend trickles down from a ring in a royal portrait to one inspired by it available in a modern mall. Sometimes, however, the movement is upward. The crystals that were sold in outdoor markets in the 1970s, loose or on makeshift cords, promising peace, love, and harmony, did not transition well into the high gloss of the 1980s. But what if they were wrapped in gold wire, hung on a gold safety pin, and sold at Barneys? Or tucked in a bracelet cage of bamboo spun by a Japanese master and displayed in a vitrine at Bergdorf's? Kazuko came to New York on a Fulbright scholarship to study experimental theater, and designed scarves before selling her crystal jewelry, which was presented for years in the vitrine that greeted shoppers the moment they stepped into Barneys. Often they were also greeted by Kazuko, always dressed in white. Meanwhile, Tina Chow was a model photographed by Helmut Newton and Cecil Beaton, and painted by Andy Warhol, and the wife of restaurateur Michael Chow. In 1987 she began selling her jewelry at Bergdorf Goodman, including her signature Kyoto bracelet with rose quartz encased within, but left loose so they could rattle enough to make their presence known. Both women

1986

died too young: Kazuko in 2007 from esophageal cancer and Chow in 1992 from AIDS-related complications. Their jewelry remains highly collectable.

They Came Bearing Crystals

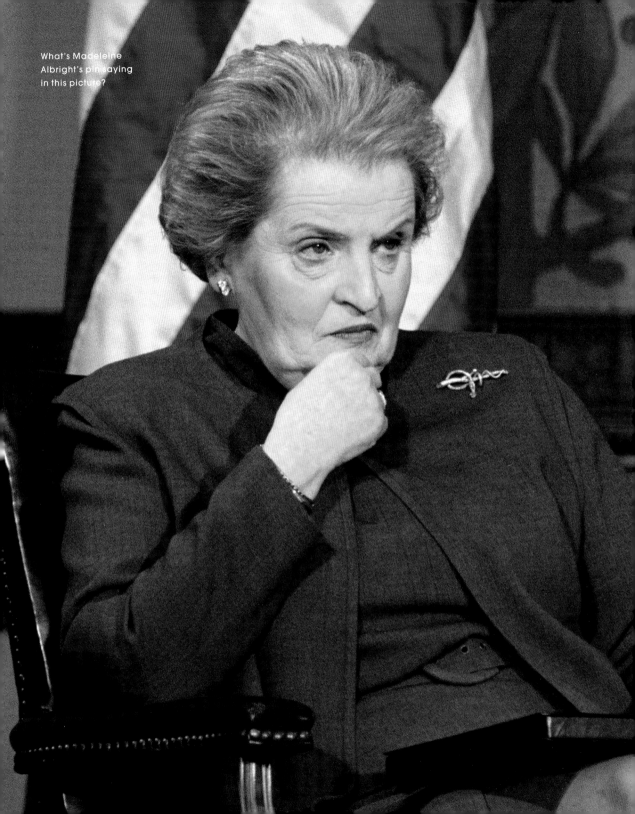

What's Madeleine
Albright's pin saying
in this picture?

Why do the world's most pow- erful women choose to
sometimes speak in pins? In 2019, Speaker of the
House of Representatives Nan- cy Pelosi wore a gold
gavel to President Trump's im- peachment hearings
months after Lady Brenda Hale, the first female president of
the British Supreme Court wore a sparkling spider brooch to announce
the court's unanimous ruling that Prime Minister Boris Johnson had ille-
gally suspended Parliament. They were both continuing the tradition of
"jewel box diplomacy," set forth by former Secretary of State Madeleine
Albright, who used her extensive collection of pins to telegraph messag-
es and mood (butterflies or flowers when things were going well, a crab to
indicate progress was happening slower than she would like). The clear-
est jewelry missive was when Albright was the Ambassador to the United
Nations under President Clinton. "Saddam Hussein called me an unpar-
alleled serpent," Albright explained. "I had this wonderful antique snake
pin. So when we were dealing with Iraq, I wore the snake pin." Though
some assumed Albright's pins were merely decorative, others caught on.
Vladimir Putin reportedly told
President Clinton that he knew
how a meeting might go de-
pending on the pin Albright
wore on her left shoulder.

1994

Brooch Diplomacy

On a Bed of Bulgari

Jewelry as plot point: it might be a bit difficult to imagine Martin Scorsese as a jewelry guy, but one of the defining jewelry moments in cinematic history occurs in *Casino*, his 1995 epic about Las Vegas and the Mafia. Let's cut to Ace and Ginger soon after their wedding, moments after he carries her over the threshold into their new home:

ACE and GINGER lie on the bed, surrounded by jewelry.
GINGER is swathed in the chinchilla coat. Ace watches as a transfixed GINGER
tries on gold necklaces, rings, bracelets and earrings.

GINGER
So, do you think it's too much if I wear these in the same day?

ACE
You do whatever you want. Do I keep my promises, or
do I keep my promises?

It was all Bulgari, boxes and boxes of their classic Tubogas chokers, and coin medallions and cabochon colored stones. Some have pointed out that not all of it was chronologically accurate, but the impact of those boxes, filled with gold, being opened and splayed out across a bed and a chinchilla coat was none the weaker for it. In our ongoing chronicle of jewelry as plot point, the Bulgari on the bed, and Ginger's reaction to it, is the clear indicator of the currency that drives this couple's relationship, and illustrates, even more than the full-length chinchilla, the dangerously seductive glamour of Ace and Las Vegas.

1995

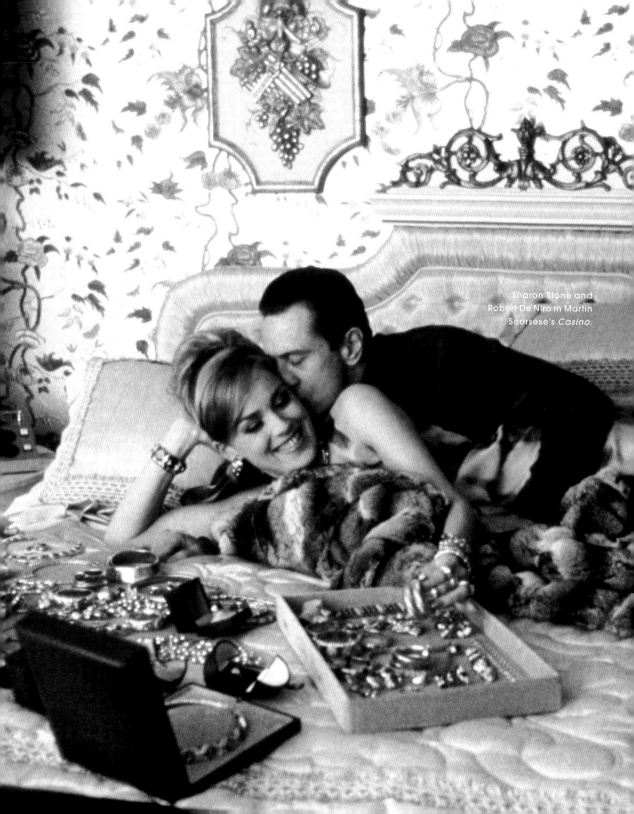

Sharon Stone and
Robert De Niro in Martin
Scorsese's *Casino*.

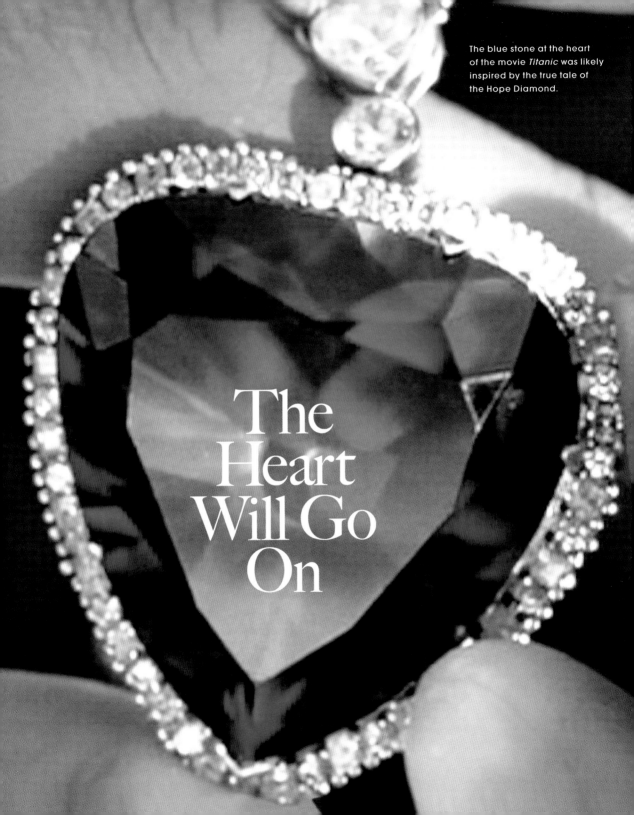

The blue stone at the heart of the movie *Titanic* was likely inspired by the true tale of the Hope Diamond.

The Heart Will Go On

James Cameron is not the first director to employ jewelry as plot point, but when a movie dives so deep into jewelry for the drama, attention must be paid. The fictional history of the fifty-six-carat blue diamond that steel tycoon Cal Hockley gives to his fiancée Rose DeWitt Bukater in *Titanic* is partially borrowed from the true saga of the Hope Diamond. Like the Hope, *Titanic*'s "Heart of the Ocean" diamond is big, rare, and blue, and belonged to the French Court until the Revolution. And it often goes missing—sending treasure hunters like the character played by Bill Paxton into a frenzy. We are still not entirely sure where the Hope went in its missing years, but the Heart of the Ocean went right into it. Why did Rose throw that beauty overboard? Many will be relieved to know what sunk down below was one of three versions of the necklace created for the movie. The jewel proved so impactful that two women wore versions of the Heart of the Ocean necklace to the 1998 Academy Awards. Celine Dion wore a 171-carat Ceylon sapphire replica of Rose's famed, if doomed, pendant, created by Asprey. It had been sold at Sotheby's days earlier for $1.4 million to benefit the Princess Diana Memorial Fund, with the provision that Dion wear it to the Oscars. But it was Gloria Stuart—at eighty-seven, the oldest person ever nominated for a Best Supporting Actress Oscar—who set the jewelry record that night. Her fifteen-carat blue diamond set in a diamond necklace by Harry Winston remains one of the most expensive jewels to ever walk a red carpet. Price tag: $20 million.

1998

The more casual the
daily uniform, the bigger
the diamond?

The Yoga Pant Index

Here's a pet theory: the year Lululemon opened their first freestanding store was a great one for jewelry. Why? Because the more casual the look you see is, the more important the accessories. As the company's bottom line grew, so did the size of their fans' diamond studs and engagement rings. Signifiers of status are a primal need in certain sectors, and if everyone at the cappuccino bar is wearing the same black leggings, rank shall be displayed in other ways: in visibly expensive earrings, in a tangle of diamond initial charm necklaces, in multiple stone bands, and carefully arranged stacks of Cartier bangles.

2000

Ben Affleck, Jewelry Psychic

Jennifer Lopez in pink and white diamonds through the years.

In 2002, Ben Affleck went to Harry Winston to see about a pink diamond. Some say that it was just because Jennifer Lopez, his then-girlfriend, liked the color pink. But might he also be a jewelry visionary with an eye for the future of stones and great investments? "It was a very rare and very precious colored diamond that most people were unaware of at the time," says a jewelry insider familiar with the sale. Pink diamonds, of course, have been prized by collectors for centuries. The Princie pink diamond, which sold at Christie's in 2016 for over $30 million, was first spotted over three hundred years ago. But white diamonds had until the late 1990s dominated the market and the public's imagination. That can be partly attributed to the DeBeers Diamond is Forever advertising campaign, partly to the lack of official vocabulary to define colored diamonds, and also because there are just so many more white diamonds out there. The Bennifer engagement ring was certainly one of the first times a pink diamond made international news. Now it seems there is a record-breaking colored diamond every year. They have become the most coveted stones in the world, highly sought-after trophy jewels inciting bidding wars at auction. In 2009, the Vivid Pink, five carats of cushion cut fancy pink, sold at Christie's Hong

2002

Kong for $11 million. In 2016, a pear-shaped fancy vivid that clocked in at nine carats sold for $18 million, and in 2017 a 15-carat fancy vivid pink sold for $32 million. And then there is the Pink Legacy, which set a world auction record when it sold at Christie's Geneva for $50 million in 2018. No word on whether Mr. Affleck received a commission.

2002

They roamed the galleries in darkness, the masterpieces in each case illuminated only by the small flashlight each had been given with admission. They filled the galleries at Somerset House to see the jewels of Joel Arthur Rosenthal, known as JAR. For most, it would be the first and last time to see the genius's work up close. Rosenthal is considered by many to be the master of all modern jewelers, the Cartier or Fabergé of our time. The London exhibition was the first public showing of his work. It would be followed by an exhibition at the Metropolitan Museum of Art in 2013, and some also got to see his work in person during previews for the 2006 sale of Ellen Barkin's jewelry at Christie's. There is a shop on the Place Vendôme in Paris, but please don't ring the bell. Clients must be introduced and, legend has it, approved. Rosenthal is a modern master who has the priv-

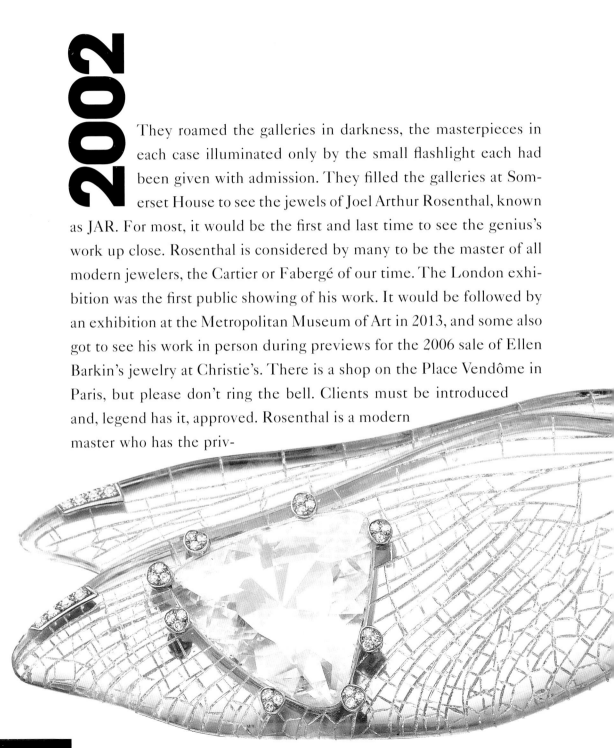

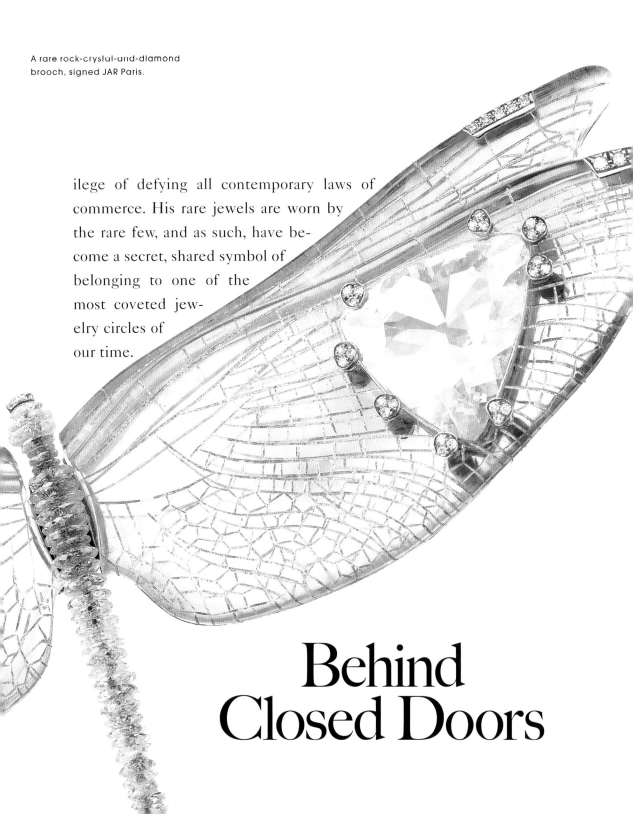

A rare rock-crystal-and-diamond brooch, signed JAR Paris.

ilege of defying all contemporary laws of commerce. His rare jewels are worn by the rare few, and as such, have become a secret, shared symbol of belonging to one of the most coveted jewelry circles of our time.

Behind
Closed Doors

Banned Substances

Although they are considered the best in all the world, when the US banned the import of all rubies (and jade) from Myanmar in light of human rights abuses, jewelers began to seek out other stones to fill red moments in their imagination. (Europe, Canada, and Australia also forbade their use.) Other sources of rubies appear (those from Mozambique are particularly prized), but jewelers also look elsewhere to satisfy the need for red. Spinels, red tourmaline, and rubellite enter into designs long dominated by precious (diamond, emerald, ruby, sapphire) and semi-precious stones (basically everything else), and the recognition of the beauty of a wider variety of stones render the division all but obsolete. The prohibition was strengthened by the JADE Act of 2008, upheld by President Obama in 2013. The ruby ban was officially lifted in 2016, though certain jewelers continue to avoid material from this region. Connoisseurs still ask if a ruby is Burmese—they likely always will—but the void created by the ban inextricably expanded the modern jeweler's palette and lexicon.

2003

Jewelry Likes

The first image uploaded to Instagram was a picture of a golden retriever and a foot in a flip flop outside a taco stand. There were no jewels visible, not even an ankle bracelet. But the same way the platform made stars out of avocado toast and Italian sunsets, so too, enormous diamonds, initial charms, celebrity engagement rings, royal wedding tiaras, and red carpet lapel pins. Early jewelry Instagram adopters such as Marion Fasel (@theadventurine) and Katerina Perez (@katerina_perez) and Natalie Bos Betteridge (@jewelsdujour) and Danielle Miele (@gemgossip) engaged followers with appealing sparkle, but also began a conversation about jewelry history and design that heightened appreciation of the industry, increasing coverage across many media. Jewelry, of every variety and era, became a topic of debate and desire, and jewelry-focused accounts continue to proliferate, igniting passion and smashing the old barrier between the wider public and jewels they may never own or get to see in person, but can, through posts, still appreciate. And jewelry's long-running campaign to be seen as decorative art receives a tremendous endorsement with each red heart.

2010

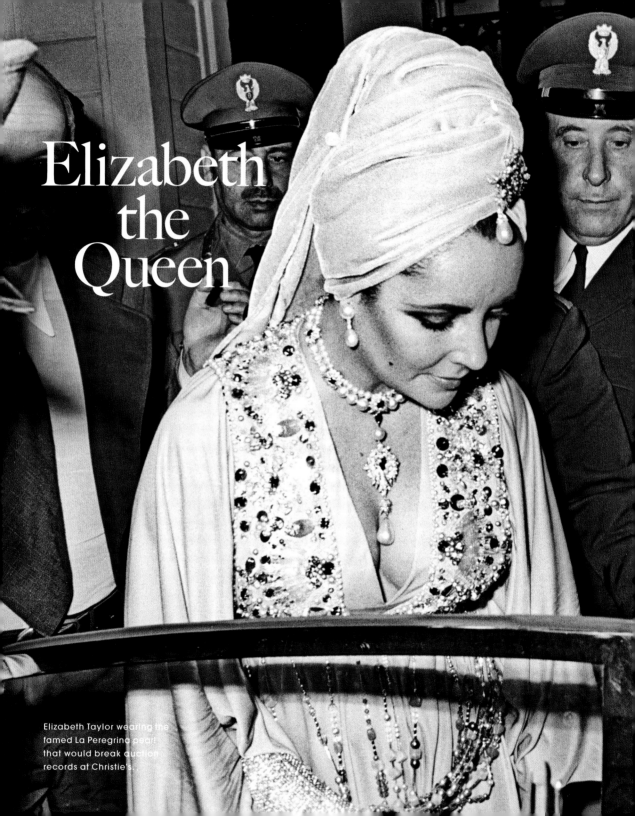

Elizabeth
the
Queen

Elizabeth Taylor wearing the famed La Peregrina pearl that would break auction records at Christie's.

Those who visited the previews of the Elizabeth Taylor sale at Christie's remember seeing the charm bracelet and the enamel Flag necklace and can vividly recall their plan to bid on one. Estimates were hardly low—between $11,000 and $30,000—but they seemed reasonable for a piece with the Taylor provenance. They sold for hundreds of thousands of dollars. Plans were dashed, but records were broken: for a ruby, for Indian jewelry, for colorless diamonds, for pearls. It was a landmark event that brought in over $156.7 million, the most valuable jewelry sale in history. The Bulgari pieces did extremely well, as did the Van Cleef & Arpels, and the Cartier. But nothing proved to be a hotter property that night than the sixteenth-century La Peregrina, a legendary pearl that began its journey to the Christie's sales room, where it sold for $11.8 million, on the coast of Panama in the early 1500s. It had been presented by an explorer to Ferdinand I of Spain and stayed largely in the Spanish treasury save for brief sojourns with the English royal they called Bloody Mary. It was painted by Velázquez and Goya and was present at the wedding of the Sun King (on the brim of Philip V's hat). After Napoleon's conquest, La Peregrina left Spain in 1813 and stayed in France until Louis Napoleon's money troubles forced him to sell it to a British noble family. They kept it until the late 1960s. It 1969, La Peregrina met Richard Burton. He knew just the woman who would like this very big, very important pearl being sold at Sotheby's Parke Benet for $37,000. And she did.

2011

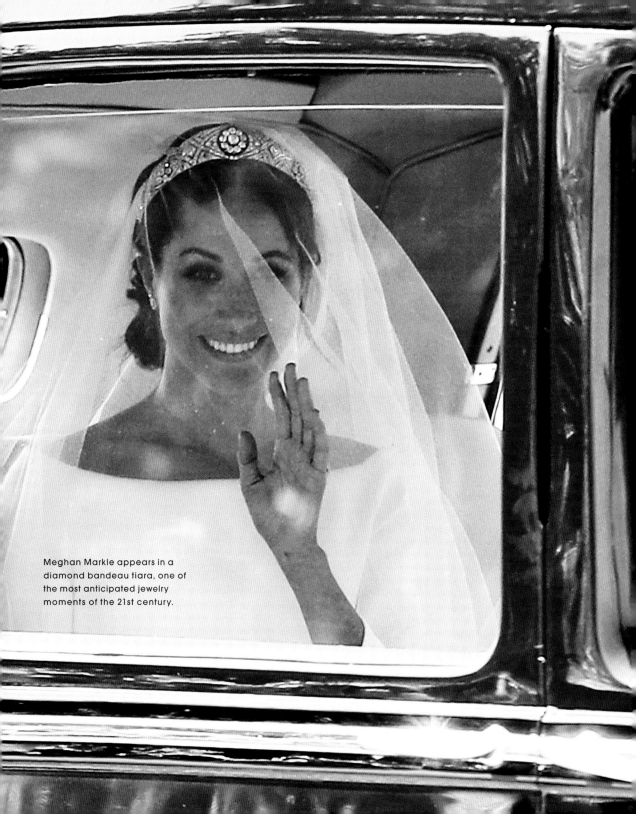

Meghan Markle appears in a diamond bandeau tiara, one of the most anticipated jewelry moments of the 21st century.

#TIARAWATCH

In the end, it really was a very classic tiara. In the art deco bandeau style, made in 1932, with a center diamond given to Mary of Teck in 1893 from the County of Lincoln for her wedding to then-Prince George, Duke of York. Mary bequeathed it to her granddaughter Elizabeth, and the Queen loaned it to the soon-to-be Duchess of Sussex on her wedding day. But had any tiara been so widely and wildly anticipated, had any other royal crown been so reported on and photographed and posted? The nuptials of Prince Harry and Meghan Markle were truly the first of the social media age (Prince William and Kate Middleton's in 2011 was technically, also of this age, but we were in the early days of Instagram). In advance of the wedding, an entire industry rose around expertise in royal jewels. Multiple articles were written and millions of images posted with headlines like "Analyzing Every Tiara Meghan Markle Could Wear at the Royal Wedding." In the process, a new trove of knowledge around the royal collection was disseminated. Many knew about the Spencer tiara, since it was worn at Princess Diana's widely watched wedding, but when was the last time people talked about the Strathmore Rose? Or Queen

Mary's Fringe? The Triumph of Love? And since when could more than a very small group accurately define kokoshnik? Or articulate the specific qualities of a diadem? The wedding was inarguably an international event but it makes history for its incredible achievement in expanding the jewelry lexicon.

2018

No one was sure it even still existed. It had been created by Boucheron in 1919 but the Greville Emerald Kokoshnik Tiara had not been seen in public in almost a century. It was thought to still be a part of the royal treasury since being gifted to the Queen Mother by Margaret Greville but did they still have it? Had it been sold off? Perhaps taken apart and used in new, more wearable pieces? Princess Eugenie's appearance outside the entrance to Saint George's Chapel as she was about to marry Jack Brooksbank answered the question. Her wedding might also mark the first time the tiara has ever been worn by a royal. Her choice also educated the world about one of the twentieth century's great jewelry collectors and greatest jewelry gifts: the Greville Bequest. Eugenie's tiara was in the Kokoshnik style, popular in the late nineteenth and early twentieth centuries and inspired by the halo-shaped headdress worn with traditional Russian costume. In terms of jewelry scholarship only, this 2018 royal wedding was the goldmine.

The Big Reveal

And Gaga Makes Three

How to make history? Wear one of the world's most historic diamonds on the Oscar red carpet when nominated for your star turn in *A Star is Born*. And make it the 128-carat yellow Tiffany diamond. And be only the third woman in the world to ever wear it in public. First Mrs. Sheldon Whitehouse at a Tiffany Ball in Newport in 1957. Then Audrey Hepburn. The Tiffany diamond Lady Gaga wore to the 2019 Academy Awards began as a 287-carat hunk of rough stone discovered in the Kimberley mines of South Africa in 1877. It was acquired by Charles Lewis Tiffany a year later, who entrusted it to his

famed gemologist George Frederick Kunz. It was immediately recognized as a treasure and became something akin to an American crown jewel. It was exhibited at the 1893 Chicago World's Fair. Only a few years later it graced the neck of Audrey Hepburn, at the center of a Jean Schlumberger diamond ribbon necklace for promotional photos for *Breakfast at Tiffany's*. (In 1995

The Tiffany Diamond has only been worn by three women. Here are two.

the stone was set in another Schlumberger piece, Bird on a Rock, for a museum show in Paris.) In 1972 Tiffany placed a possibly tongue-in-cheek ad in the *New York Times* offering it for $5 million (about $25 million today) to anyone who could come up with the money in a strict twenty-four hour period (any checks mailed after that date would be returned with thanks). In 2012 the diamond was set in its current diamond-necklace setting for Tiffany's 175th anniversary. A week after the Oscars the diamond was back home, in a vitrine with pride of place on the main floor of Tiffany's Fifth Avenue flagship, where you can visit it anytime you'd like.

The Survivor

The Dresden Green Diamond was spared during a heist at the Dresden Green Vault.

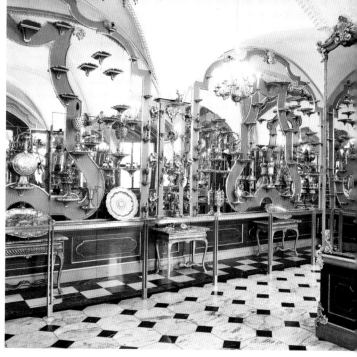

Let's end, why don't we, with another history-defining twist of fate: The Dresden Green Diamond began its auspicious path in the Kollur mines of India, where it was discovered by a British merchant in 1722 and presented to King George, who displayed little interest—our first twist. It ended up instead in the royal court of Saxony as part of the emblems of the Order of the Golden Fleece, but that too was short-lived. Frederick of Saxony decided he'd like to wear it on his hat; diamonds were added and it was set as a pin, as it remains. It entered the confines of the Dresden Green Vault and remained there for almost three hundred years, briefly captured by the Soviets during World War II, only to be returned shortly after. It made a trip to the United States under the auspices of Harry Winston to visit the Smithsonian. But back to Dresden it went, and where it should have been on November 25, 2019, when thieves broke in and stole countless historic treasures. The most priceless of all, the rare Dresden Green Diamond, the largest of such a gem in the world, was nowhere in sight. Because it was safe in a second-floor gallery at New York's Metropolitan Museum of Art, on loan for an exhibition. History that might have been lost forever, saved by happenstance.

2019

Credits

Great Jewelry Collections of the World

Below are some of my favorite places to go in search of historic jewels. They are not always easy to find—even in the museums listed here—but they are there, and seeing jewelry alongside paintings and sculpture and other decorative arts is illuminating.

Africa:

Royal Jewellery Museum
Alexandria, Egypt

The Egyptian Museum (Museum of Egyptian Antiquities) *Cairo, Egypt*

The Museum of Gems and Jewellery
Cape Town, South Africa

Asia:

Jewellery Gallery, National Museum
New Delhi, India

Mikimoto Pearl Island
Toba, Japan

World Jewellery Museum
Seoul, South Korea

Australia:

Museum of Applied Arts & Sciences
Ultimo, New South Wales, Australia

Europe:

The Crown Jewels, Tower of London
London, England, United Kingdom

The British Museum
London, England, United Kingdom

Victoria & Albert Museum
London, England, United Kingdom

Department of Decorative Arts, Louvre Museum *Paris, France*

Munich Residenz
Munich, Germany

Pforzheim Jewellery Museum
Pforzheim, Germany

Benaki Museum *Athens, Greece*

Ilias Lalaounis Jewelry Museum
Athens, Greece

National Archaeological Museum
Athens, Greece

Museum of Jewellery in the Vía de la Plata
La Bañeza, León, Spain

North America:

Gallery of Gems and Gold, Royal Ontario
Museum *Toronto, Ontario, Canada*

Museo de Artes Populares Belber Jiménez
Oaxaca, Mexico

Gemological Institute of America
Carlsbad, California, United States

Boardman Collection of Contemporary
Jewelry, Los Angeles County Museum of Art
Los Angeles, California, United States

National Gem & Mineral Collection,
Smithsonian National Museum of Natural
History *Washington, D.C., United States*

The Art Institute of Chicago
Chicago, Illinois, United States

Museum of Fine Arts
Boston, Massachusetts, United States

The Jewelry Collection, Millicent Rogers
Museum *El Prado, New Mexico, United States*

American Museum of Natural History
New York, New York, United States

Cooper Hewitt Smithsonian Design Museum
New York, New York, United States

The Metropolitan Museum of Art
New York, New York, United States

Wertz Gallery of Gems & Jewelry,
Carnegie Museum of Natural History
Pittsburgh, Pennsylvania, United States

South America:

Museu Afro Brasil *Sao Paulo, Brazil*

Museo del Oro *Bogotá, Colombia*

Acknowledgments

Can you use jewelry to tell the history of the world? It's a question I've spent most of my career trying to answer, and so thank you Rizzoli and Charles Miers for letting me do exactly that. I could not have attempted the inquiry into the stones, myths, and legends of jewelry culture without the guidance of the power trio of my editor Caitlin Leffel, designer Matt Berman, and photo researcher Supriya Malik. After two jewelry books with me Caitlin is now a certified jewelry person—which might make buying her gifts more difficult, but also gives her husband access to my advice any time. Matt, thank you for bringing your knowledge and trademark wit to each page. I remember wanting to work together from when I watched you in the halls of 1633 Broadway as an intern and then as each cover of *George* appeared, and now every time you tag me on Instagram in a vintage picture of anyone wearing jewelry. I love what we all created together.

How, people have asked me, did you manage to put together this book while also putting together a magazine? It took me a year—twenty-plus years and a year, to be clear. And it took all my jewelry teachers whose lessons and revelatory insights are evident on every page. I was taught to look at jewelry the way I do by people like Audrey Friedman, Ralph Esmerian, Marion Fasel, Penny

Proddow, Vivienne Becker, Jill Newman, and Inezita Gay-Eckel. These are the men and women who generously gave of their knowledge and their incredible collections along the way. And then there are those who I call on regularly, sometimes daily. I call them the Jewelry Mafia: Rebecca Selva, Frank Everett, Lee Siegelson, Daphne Lingon, Claiborne Poindexter, Jeffrey Post, Mahnaz Ispahani Bartos, Nicolas Luchsinger. You are all my secret power.

I'm grateful for the doors jewelry has opened for me, and the secret vaults (including the one at the Smithsonian, for researching this book) but especially that it is what first led me through the entrance of *Town & Country*, a magazine that has always respected jewelry as cultural artifact and decorative art. I thank all the editors that went before me at *T&C* and the incredible ones there now and who support this jewelry obsession of mine in any way they can.

As always, the final and strongest word of thanks goes to my family: my parents John and Marcella, brother Peter and sister-in-law Sophia, and my nieces Cayla and Paige. You started this whole jewelry thing and I'm incredibly proud that it seems like it will just keep on going and going.

First published in the United States of America in 2020 by
Rizzoli International Publications, Inc.
300 Park Avenue South
New York, NY 10010
www.rizzoliusa.com

Copyright © 2020 Stellene Volandes

Publisher: Charles Miers
Editor: Caitlin Leffel
Creative Direction and Photo Research: Matt Berman
Art Direction: Danlly Domingo
Production Manager: Alyn Evans
Rights and Permissions: Supriya Malik
Managing Editor: Lynn Scrabis

Printed in Italy

2020 2021 2022 2023 / 10 9 8 7 6 5 4 3

ISBN: 978-0-8478-6854-4
Library of Congress Control Number: 2020935610

Visit us online:
Facebook.com/RizzoliNewYork
Twitter: @Rizzoli_Books
Instagram.com/RizzoliBooks
Pinterest.com/RizzoliBooks
Youtube.com/user/RizzoliNY
Issuu.com/Rizzoli